Introduction

As the Internet becomes more accessible, and computer software and hardware becomes more affordable, more and more people are setting up sites on the World Wide Web. New, advanced software allows even the inexperienced computer designer to set up a sophisticated site. The rapid increase in number does not necessarily mean that the quality has increased alongside. Rather, the influx just means that Web-surfers must wade through much more material in order to find the quality sites.

Designing a Website is much more complex than just creating a computerized version of traditional design project. As in all projects, the designer must consider the personality of the client, the purpose of the site, and the targeted end-user when creating the site. Even more, the designer must take into account the fact that the end product will not be the same for every user. A good Web design will be strong despite the many different ways the user will see it and the many different settings available to the computer user.

The designers in this book have taken all those factors into account in their designs and successfully created a Website that has attracted many repeat visitors. Whether created with simple graphics or tons of action, each design is successful for its market. Screen shots can only do the sites limited justice, the interactive-ability of the medium is what makes Websites so unique. This book is a mere sampling of the great designs on the Web; use this book for inspiration to do some surfing of your own!

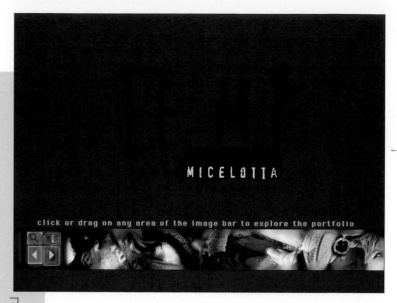

WOW Sight + Sound designed these three photography portfolios around the principle that end use determines the success or failure of interactive media products. Each promotional piece was designed to reflect the photographer's visual style and to provide an innovative environment for the photographer's work.

The portfolio for MTV photographer Frank Micelotta begins with a lively opening sequence, then segues into a palette bar displaying a montage of the photographer's images. The interface palette offers three ways of viewing the photographer's work: clicking on the palette brings up a specific image; dragging an image from the palette to the interface desktop; or using the forward/backward arrows to view each image consecutively. Appropriate sound bites accompany each image as it appears on the screen, and a magnifying glass is supplied for viewing larger images.

* * *

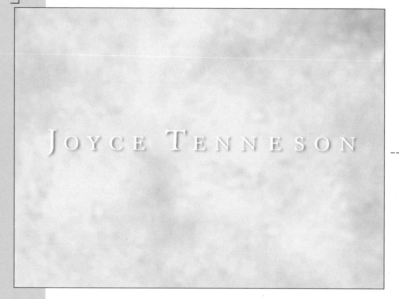

The design of Joyce Tenneson's portfolio takes a different approach in presenting the photographer's work. During the opening sequence the photographer discusses her style and reminisces about her work, while photos from the portfolio fade in and out.

The portfolio is characterized by extreme simplicity and elegance, aptly reflecting the photographer's work—each photograph is displayed by clicking on its thumbnail image located in a row across the bottom of the screen.

* * *

The designers at WOW developed yet another navigational device for Michel Tcherevkoff's portfolio. The opening features an animated slide show accompanied by moving type and a jazzy, upbeat sound loop.

As with Joyce Tenneson's portfolio, the interface is clean and simple. The user traces a line of curved text ("Naked, you are simple as a hand…") with the cursor to reveal the portfolio images.

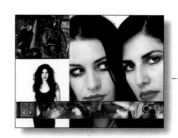 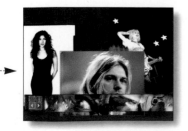

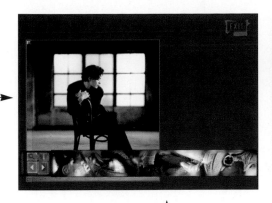
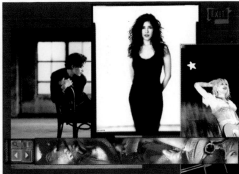

Project: **Photographer's Portfolio**
Client: **Frank Micelotta**
Photography: **© Frank Micelotta**
Design Firm: **WOW Sight + Sound**
Designers: **Abby Mufson,**
Darell Dingerson, John Fezzuoglio
Programmers: **Darell Dingerson**
Platform: **Mac**

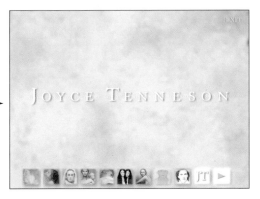
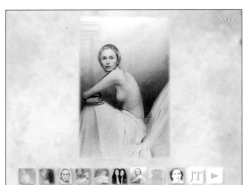

Project: **Photographer's Portfolio**
Client: **Joyce Tenneson**
Photgraphy: **© Joyce Tenneson**
Design Firm: **WOW Sight + Sound**
Designers. **Abby Mufson,**
John Fezzuoglio
Programmers: **Abby Mufson,**
Darell Dingerson
Platform: **Mac**

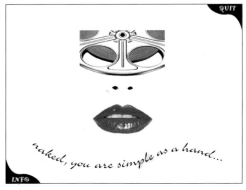

Project: **Photographer's Portfolio**
Client: **Michel Tcherevkoff**
Photography: **© Michel Tcherevkoff**
Design Firm: **WOW Sight + Sound**
Designers: **Abby Mufson, Alec Cove**
Programmers: **Abby Mufson, Alec Cove**
Platform: **Mac**

DIGITAL PORTFOLIO

Ribit Productions Inc.'s portfolio is simple in design, yet extremely effective in capturing the attention of the user.

The piece opens with a parody of da Vinci's familiar "Diagram of Man" sketch in the form of a frog, which morphs into a more realistic frog rendering before jumping off screen and into the company's logo. The software gives a quick overview of the important strengths of the design firm—a wise strategy to follow, considering the time constraints of many potential clients.

The designers have created a warm and enjoyable portfolio without the mechanical coldness of buttons and hard edges that characterize many other portfolios; the navigational bar at the bottom of the screen is composed of four da Vinci sketches that, when clicked, take the user to four different examples of the company's work.

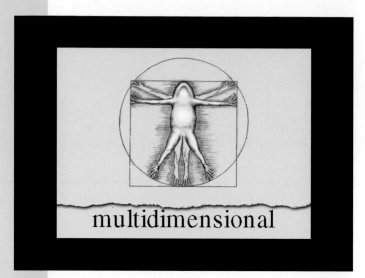

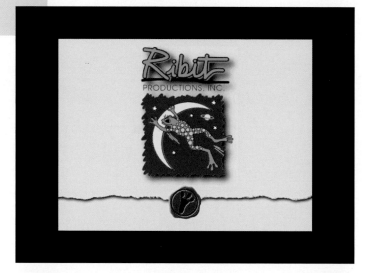

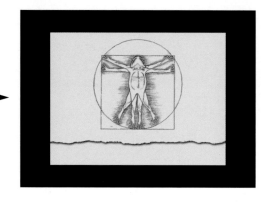

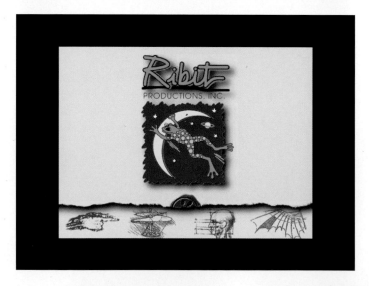

Project: **Digital Portfolio**
Design Firm: **Ribit Productions Inc.**
Designers: **Ronda Bailey, Sean Wu**
Illustration: **Ronda Bailey, Sean Wu,
Scott Lumley**
Programmers: **Ronda Bailey, Sean Wu,
Mindy Miller**
Authoring Program: **Macromedia Director**
Platform: **Mac**

ECCO's *Cricket* design project has no visible buttons for content navigation. The interface is designed so that rollovers reveal hierarchical indexes that light up when activated by the cursor. The text in these indexes leads to other screens in the presentation, where rollovers again are used to highlight important aspects of *Cricket*.

To navigate back and forth through the interface, the designers used an innovative rollover sequence in the upper-left corner with a large plus sign that highlights clickable left/right arrows when the cursor moves across it.

This form of navigation could be cumbersome and hard to work with in a larger program, but for a small, floppy disk-sized design such as this, its features allow easy navigation.

E	C
C | O

ECCO Design Inc.

Industrial Design and Product Development

ECCO PRESENTS...
About...

I.D.
40th
Annual
Design
Review

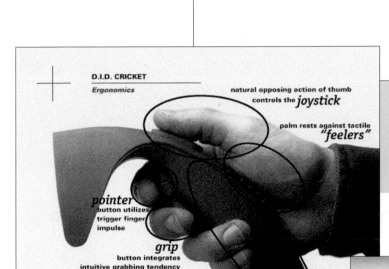

D.I.D. CRICKET
Ergonomics

natural opposing action of thumb controls the *joystick*

palm rests against tactile *"feelers"*

pointer
button utilizes trigger finger impulse

grip
button integrates intuitive grabbing tendency

handle
designed for left and right handed users

D.I.D. CRICKET
Controls

Simulation
Controls
Ergonomics

D.I.D. CRICKET
Controls

CHOOSE items with the trigger

MAGNETIC positioning sensor

MOVE around with the joystick

HOLD virtual objects by squeezing the grip

ULTRASONIC microphones for tracking

TOUCH objects with tactile "feelers"

Project: *ECCO Cricket*
Design Firm: **ECCO Media**
Designers: **Eyal Eliav, Eric Chan, Philip Fierlinger**
Programmer: **Philip Fierlinger**
Authoring Program: **Macromedia Director**
Platform: **Mac**

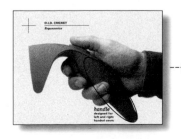

URL: http://www.teknoland.es/arte/fura/

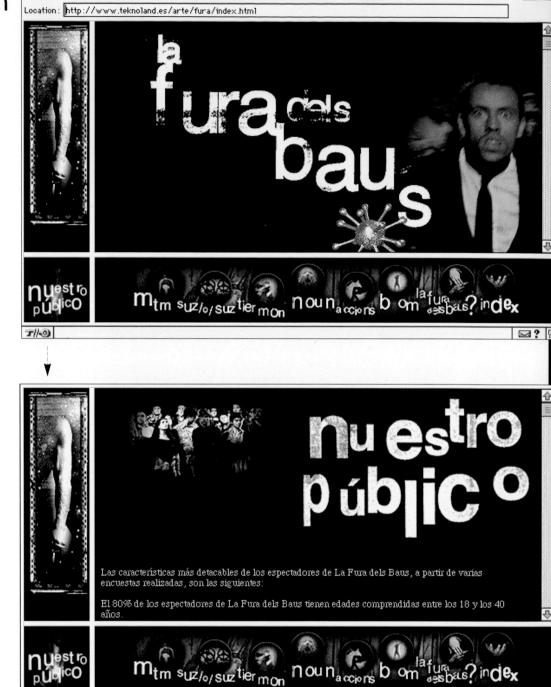

ENTERTAINMENT

La Fura dels Baus is an innovative Spanish performance company whose artistry was featured at the 1992 Olympic Games in Barcelona. The monolingual Spanish Website, created by Teknoland as an offshoot of the design firm's self-promotional Website, uses frames to divide the screen into four areas: a scrolling main center screen, two linking areas ("Nuestro Público" and the lower menu bar), and one vertical image display area.

This Website relies on computer-enhanced photographic images, rather than illustrations, enhancing the dramatic realism of the theatrical group's work. Gritty text, roughened frames, and dark backgrounds add to this effect—the black background is more a stage than a background, which incidentally improves the download time of the entire site.

The vertical image frame at the left of the browser window is an image chooser. Images selected here appear full-size in the large window. These images have been artistically manipulated and show a great sense of controlled mystery, as shown in the vertical image bars to the right.

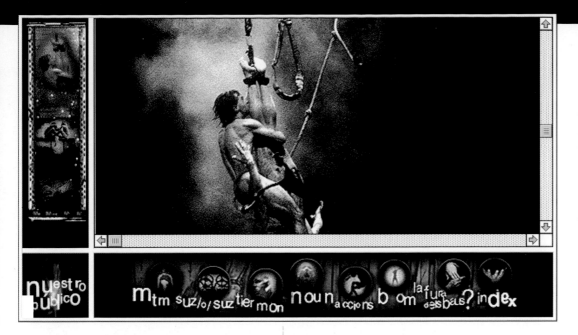

Scrolling text is placed in the main window over a black background. The image to the top left uses a wide monotone photographic image very effectively. The type is still readable over it, and the use of a limited color palette helps the site download more quickly.

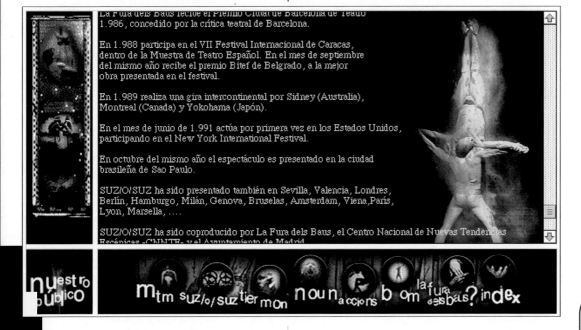

La Fura dels Baus recibe el Premio Ciudad de Barcelona de Teatro 1.986, concedido por la crítica teatral de Barcelona.

En 1.988 participa en el VII Festival Internacional de Caracas, dentro de la Muestra de Teatro Español. En el mes de septiembre del mismo año recibe el premio Bitef de Belgrado, a la mejor obra presentada en el festival.

En 1.989 realiza una gira intercontinental por Sidney (Australia), Montreal (Canada) y Yokohama (Japón).

En el mes de junio de 1.991 actúa por primera vez en los Estados Unidos, participando en el New York International Festival.

En octubre del mismo año el espectáculo es presentado en la ciudad brasileña de Sao Paulo.

SUZ/O/SUZ ha sido presentado también en Sevilla, Valencia, Londres, Berlín, Hamburgo, Milán, Genova, Bruselas, Amsterdam, Viena, Paris, Lyon, Marsella,

SUZ/O/SUZ ha sido coproducido por La Fura dels Baus, el Centro Nacional de Nuevas Tendencias Escénicas -CNNTE- y el Ayuntamiento de Madrid.

a ccio ns

El espectáculo ACCIONS es una alteración física de un espacio. Es un juego sin normas; una cadena de situaciones límite; es una transformación plástica en un terreno inusual.

ACCIONS es un montaje operativo. Se manipulan productos residuales para conseguir una proyección escénica distorsionada Las actuaciones se efecúan en diferentes zonas de

Project: **Teknoland**
Design Firm: **Teknoland**
Art Director: **David L. Cantolla**
Designer: **Jose Luis Garcia**
Programmers: **Colman Lopez, Jesus Suarez**
Authoring: **Nestor Matas, Michael Mangicotti**
GIF89a animations: **Jose Luis Garcia, Michael Mangicotti**
Features: **GIF89a animation, Java scripting, Shockwave, streaming audio**

Mya Kramer Design Group created an exciting and intuitive Web presence for the multimedia division of Autodesk—the maker of 3-D multimedia graphics products—with no significant previous experience in interactive Web design.

The opening page to the site depicts the mind of a multimedia designer with action words that invite the viewer to explore the pages and "experience creation," as the company's slogan goes.

Mya Kramer Design Group created the site with several objectives in mind and adhered to them strictly: the site had to allow visitors to go anywhere in three clicks or less; the downloading of a graphic could not take more than fifteen seconds; and the site had to be open and airy. All three of these objectives were accomplished. The pages within the Website download quickly, and make for an easily navigable and graphically pleasing site.

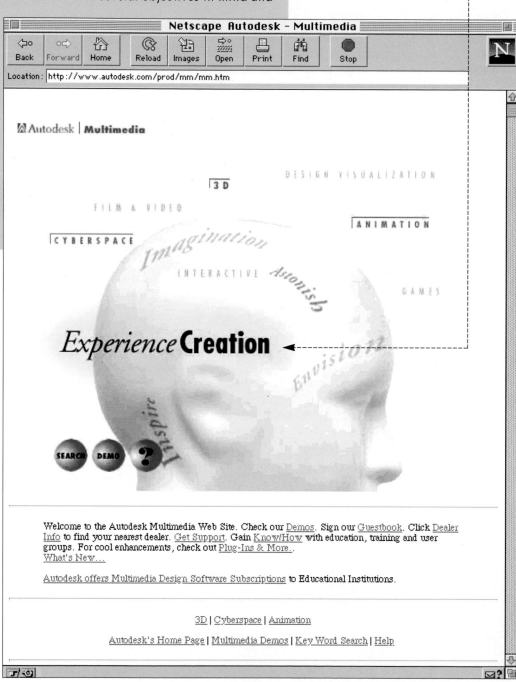

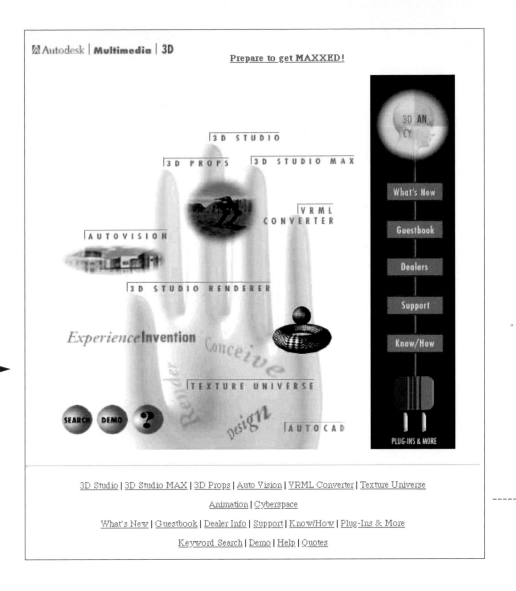

3D Studio | 3D Studio MAX | 3D Props | Auto Vision | VRML Converter | Texture Universe
Animation | Cyberspace
What's New | Guestbook | Dealer Info | Support | Know/How | Plug-Ins & More
Keyword Search | Demo | Help | Quotes

Project: **Autodesk Website**
Client: **Autodesk, Inc.**
Design Firm: **Mya Kramer Design Group**
Designers: **Mya Kramer, Amy Suits**
Programmers: **Gavin Bridgeman,**
John Kuta, Bryan Holland
Photographer: **Robert Cardin**
Authoring Program: **HTML**
Platform: **Browser Related**
URL: **http://www.autodesk.com/prod/mm/mm.htm**

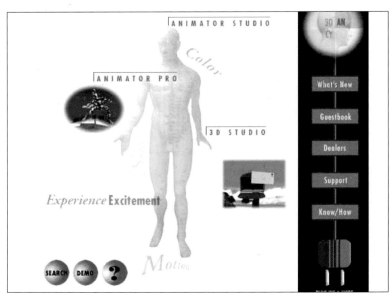

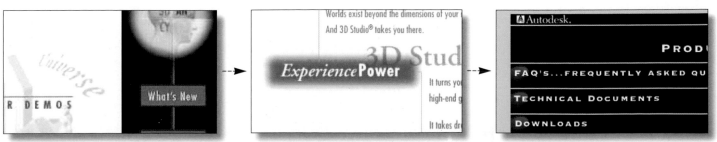

Home Financial Network's Website is an example of the potential for business functions conducted the traditional way translating to online use. A grayscale image, tiled in the background, frames the color image in the foreground, which keeps the viewer's eye focused on important areas.

Shades of green and collaged money convey the feeling of a financial institution, and the illustrated icons used for the three main buttons are well representative of the following links. On subsequent pages, the designers use color sparingly, choosing to focus the viewer's eye on icons that link to other areas of the site.

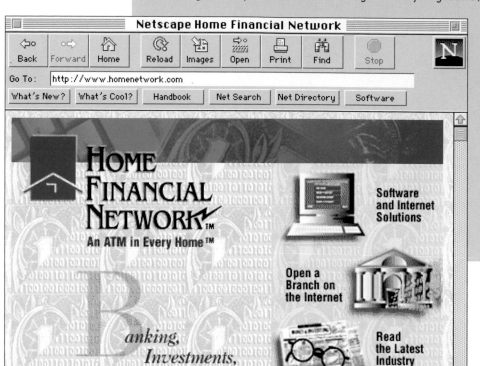

Project: **Home Financial Network Website**
Client: **Home Financial Network Inc.**
Design Firm: **The Design Office Inc.**
Designers: **Yung Beck, Dave Green, Andrea Flamini, Joe Feigenbaum**
Programmer: **Andrea Flamini**
Authoring Program: **HTML**
Platform: **Browser Related**
URL: **http://www.homenetwork.com**

Canary Studios Website's main objective was to stay away from what the designers term the "beveled edge phenomenon," referring to the look of buttons with sides shaded to appear three-dimensional. This was accomplished by creating a graphically pleasing and colorful home page illustration that perfectly represents the company.

The large canary head offers visitors and potential clients a visual punch, while the colorful buttons below the bird's head offer clear and easy access to the rest of the site.

A colorful button bar keeps the continuity of the home page design; it offers jumps to other sections with a single mouse click, never going more than one level deep into the interface..

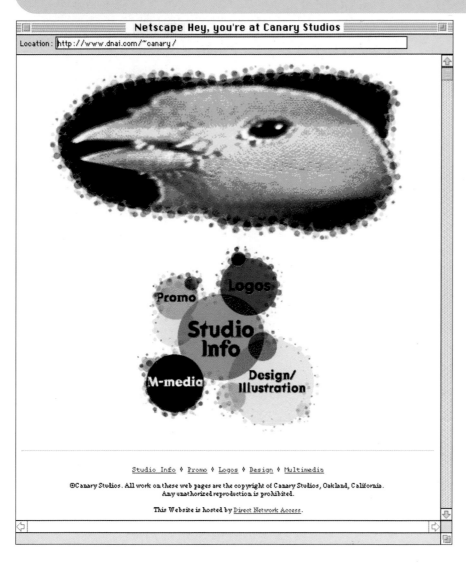

Project: **Canary Studios Website**
Design Firm: **Canary Studios**
Designers: **Ken Roberts, Carrie English**
Illustrator: **Carrie English**
Photographer: **Robert Sondgroth**
Programmer: **Ken Roberts**
Authoring Program: **HTML**
Platform: **Browser Related**
URL: **http://www.canary-studios.com/~canary**

The American Institute of Graphic Arts Website, created by Graffito/Active8, lends credibility to the organization by showing well-designed pages without using too many of the clichéd bells and whistles of Web design.

A single image icon with branching text buttons is used to navigate the contents, and is positioned at the top right of each page to give continuity to the site, adding to the ease of navigatiion.

To the left of the contents icon are buttons that link to information relating to AIGA and the services the organization offers. These buttons float on a background that changes color with each area that the user visits, adding further continuity to the design.

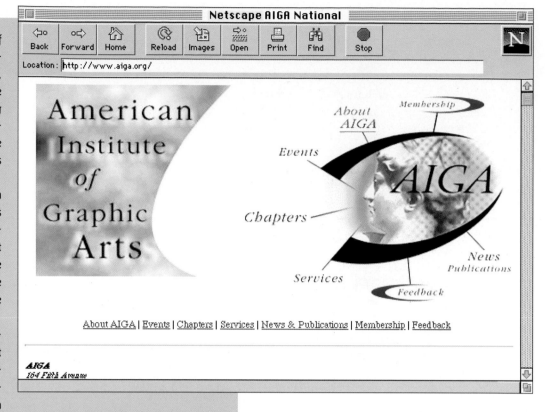

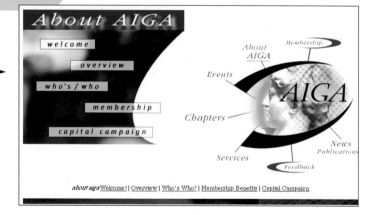

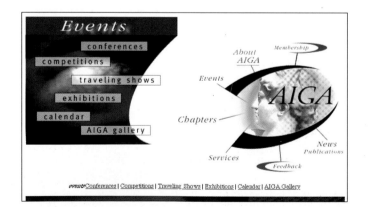

Project: **AIGA Website**
Client: **American Institute of Graphic Arts**
Design Firm: **Graffito/Active8**
Designers: **Tim Thompson, Jon Majerik**
Programmer: **Jon Majerik**
Photographer: **Morton Jackson**
Authoring Program: **HTML**
Platform: **Browser Related**
URL: **http://www.aiga.org**

MULTIMEDIA DESIGNER

imedia's Website uses the strong visual recognition of its home, San Francisco, as a graphic theme. Three consecutive images of the Golden Gate Bridge, in various states of rendering, open the Website, while banners on following pages continue the bridge motif. This establishes imedia as a strong regional design firm, with potential for global outreach.

For quicker downloads, imedia uses generous amounts of white space and smaller images to draw the viewer's eye to specific areas of the portfolio. The whimsical use of colorful shirt buttons for navigational buttons adds a touch of humor to their portfolio presentation.

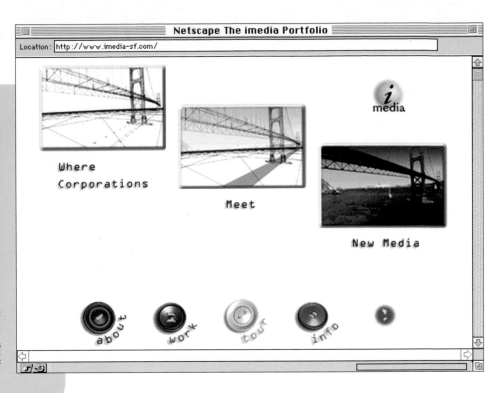

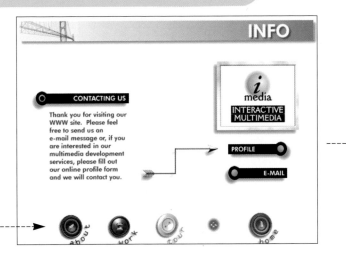

Project: **imedia Website**
Design Firm: **imedia Interactive Multimedia**
Designers: **B. Almashie, H. Campos**
Illustrators: **B. Almashie, H. Campos**
Programmers: **B. Almashie, H. Campos**
Authoring Program: **HTML**
Platform: **Browser Related**
URL: **http://www.imedia-sf.com**

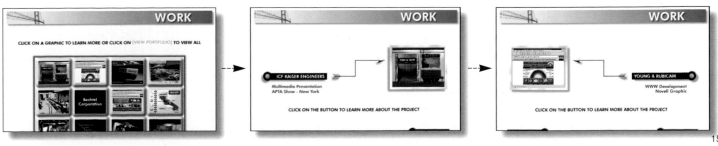

Women's Wire is the first interactive publication to recognize and address a female audience. Designed for women, by women, this online magazine is unique in its content; though the Web is predominantly male-oriented, recent statistics show that women are beginning to access the Web in larger numbers.

The site is also unique in its design, with two versions of its home page interface: a traditional, static Web design and a "Shocked" home page that uses animated fades to introduce images, and section head numerals that change colors. Both designs offer viewers a clean interface for navigation, and show how the designers understand the parallels and differences between designing for print and designing for this new media of interactive publishing.

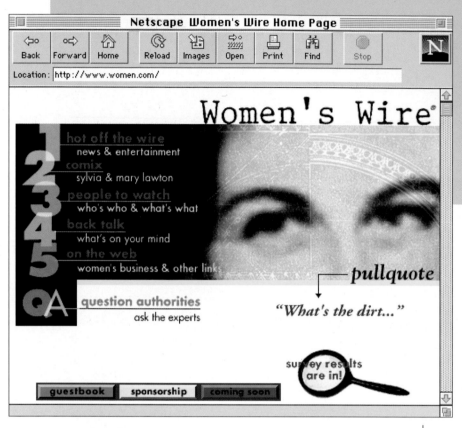

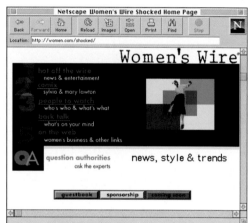

Project: *Women's Wire*
Design Firm: **Lisa Marie Nielsen Design**
Designer: **Lisa Marie Nielsen**
Authoring Program: **HTML**
Platform: **Browser Related**
URL: **http://www.women.com**

The Epson Website breaks the Web rule-of-thumb that designers should avoid using large amounts of text in their design. Instead of using graphical or icon-based buttons as the focal point, Digital Facades uses colorful typographical elements as the navigational buttons for this site. Collage images were added, producing a clean, contemporary look that invites the user to explore the different aspects of the site. Visitors to the site looking for a specific topic will find all areas clearly labeled and easily accessible.

The home page sets the tone of the project, with its large type brackets as borders for the center image. This design element is repeated on each of the main pages, along with colorful type treatments, collage, and dotted lines and arrows that give the Epson Website an artistic flavor.

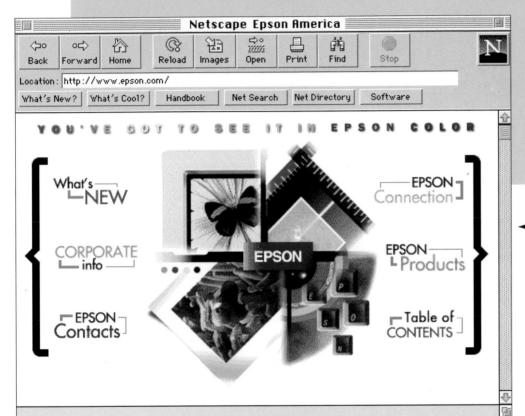

Project: **Epson America Website**
Client: **Epson America Corp.**
Design Firm: **Digital Facades**
Designer: **Oliver Chan**
Programmers: **Jane Lin, Jason DeFillippo**
Authoring Program: **HTML**
Platform: **Browser Related**
URL: **http://www.epson.com**

fontBoy's interactive catalog does one thing well that all font designers need: it gets the company's fonts seen. To achieve this end, designers Aufuldish & Warinner created several display pieces for their fonts. The fontBoy interactive catalog allows the user to view samples of fonts, print bitmapped samples of fonts, get ordering information, and find out about future releases, all within a designer-friendly environment.

In the main holding screen, letterforms float randomly in space. When the mouse passes over a letter, the letter stops moving, and the name of the font appears. Double-clicking on the letter takes the viewer to a screen that displays the full font family. This controlled chaos looks great; for the impatient, however, a directory is provided for easy access to individual fonts.

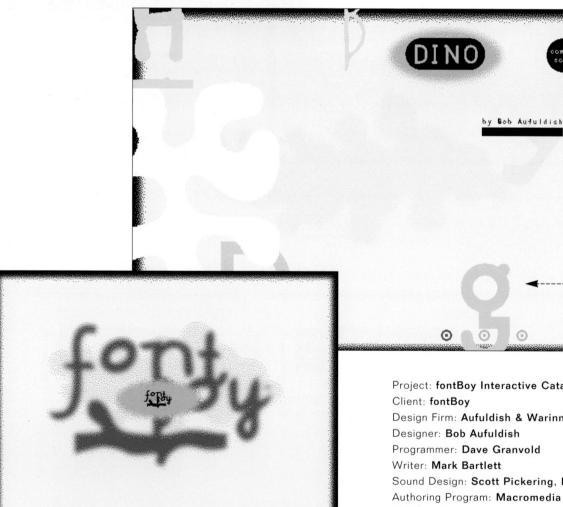

Project: **fontBoy Interactive Catalog**
Client: **fontBoy**
Design Firm: **Aufuldish & Warinner**
Designer: **Bob Aufuldish**
Programmer: **Dave Granvold**
Writer: **Mark Bartlett**
Sound Design: **Scott Pickering, Bob Aufuldish**
Authoring Program: **Macromedia Director**
Platform: **Mac**

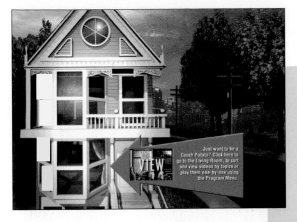

America's Funniest Home Videos' CD-ROM game, entitled *Lights! Camera! InterAction!* has something to offer couch potatoes, would-be film editors and game players.

Lights! Camera! Interaction! takes place in a suburban American house with three playing levels. Those who tear themselves away from the couch potato level will find the editing level on the second floor, and the game room in the attic.

The three levels in the house are three-dimensional rooms where all of the interaction takes place. Each level of the house requires varying degrees of user involvement. The first floor lets users sit back and run through dozens of home videos, the second floor has an editing suite where users splice together their own home videos from stock footage, and the attic lets users play a game.

The 3-D design and interactivity of the helper arrows show an unusual amount of forethought and planning, compared to help features found in most other interactive projects.

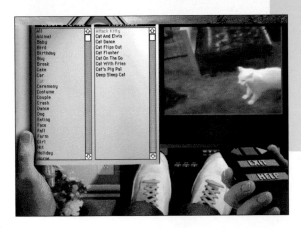

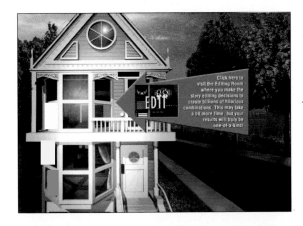

Project: *America's Funniest Home Videos Lights! Camera! InterAction!*
Design Firm: **Graphix Zone Inc.**
Designer: **Susan Dodds**
Programmers: **Bill Pierce, Sean Dunn**
Authoring Program: **Apple Media Tool Kit**
Platform: **Mac/Windows**
Production Date: **October 1995**

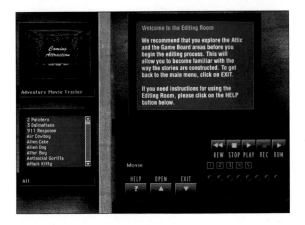

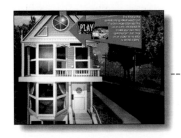

DIGITAL PORTFOLIO

Big Hand Productions' designers have realized the aim of the firm's portfolio, which is to summarize and showcase its extensive multimedia work. The design of the interface gives a feeling of movement, while the use of shading and layering evoke the illusion of a more intricate visual.

The portfolio's interface uses a single main screen for navigating its contents. This screen includes a volume slider bar, forward and backward buttons, an index button that allows the user to skip to a specific section, a background info button, and an exit button. Working with a monochromatic color scheme allows for prominent display of the design firm's projects. Big Hand's interfaces show an ability to adapt any project to multimedia, as can be seen in their designs for the "Australian Photographers" CD-ROM, Philips CD-i, and a Cadillac kiosk.

Project: **Digital Portfolio**
Design Firm: **Big Hand Productions**
Designers: **Staff**
Authoring Program: **Macromedia Director**
Platform: **Mac**

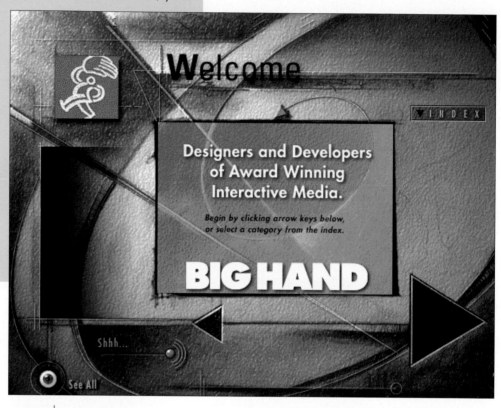

URL: http://web20.mindlink.net/ph/

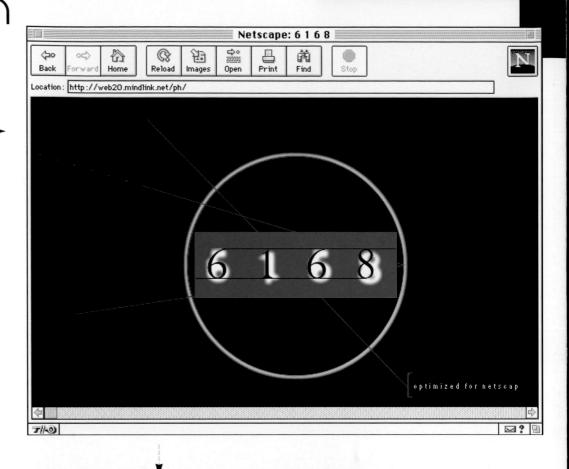

Netscape: 6 1 6 8

Location: http://web20.mindlink.net/ph/

6 1 6 8

optimized for netscap

ART EXHIBIT

6168, an online art exhibit, got its unique title from the birth dates of the site's two Canadian creators, photographer Peter Horvath and multimedia designer Sharon Matarazzo.

They have created a minimalist look at modern culture, complete with a dial-up look at *TV Guide* history. During the process of the exhibit's creation, viewers were able to contribute their own writings and designs to the site.

The designers' grasp of color theory and contemporary design can be seen throughout the site.

Single hypertext links that guide the viewer through the various stories and essays keep navigation simple.

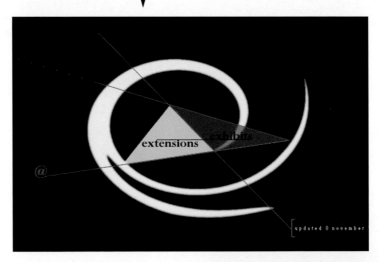

extensions · exhibits

updated 8 november

The 6168 splash page offers users a single point of entry (above). Clicking on the logo leads viewers to the main contents page (middle). Here viewers can choose the main "Exhibits" area of the site, where they can view stories composed of hyperlinks and animated GIFs (right), or click on "Extensions" and check out the creators' list of art-related links.

memory shapes who we are · memory is impression

accelerated history 7 a book of time

images are (my) tokens of memory...

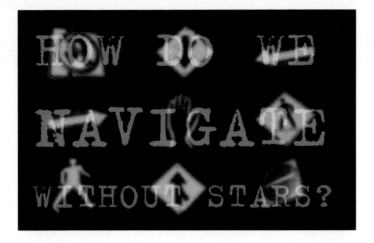

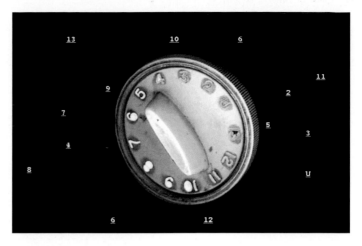

In the eyes of those unknown to me

eyes that evade, look away

and sometimes catch my own

I sense an indescribable Longing

Thursday

8:30 13 - 13

Janeane's older sister (Illeanea Douglas) visits the city for Thanksgiving, and helps herself to Jonathan. Meanwhile, Sam tries to work up the courage to fire a flaky employee (Jack Black). Paula: Lauren Bowles.

Interactive pages such as the ones above (starting clockwise from top left) force viewers to interact with the design. To stimulate viewer interest, after the word "How" pops in, the viewer must click on each successive word to finish the question. Unique designs such as the TV dial above offer an interesting layout of hypertext links. Viewing the HTML code, `<tt>1231231213`, reveals that the designers used multiple numbers colored black to move each of the numbered links into a specific position. The HREF added to the number "13" highlights the link, making it look as if it were floating by itself.

Peter Horvath was born in 1961 in Toronto, Canada. During his youth, he devoted his time to photography. In 1981, he established a studio in downtown Toronto, and spent the following years working as a photographer, developing his technical and aesthetic skills.

In 1985, and 1987 he briefly lived in Milan and Paris, respectively. When he returned to Toronto, his approach to photography had been significantly altered and shifted direction. Horvath entered a prolific period of experimentation, motivated by newly realized artistic intentions, and created a

Project: **6168**
Design Firm: **Mco Digital Productions**
Designers: **Peter Horvath, Sharon Matarazzo**
Features: **GIF89a animation**

Project: **Digital Dexterity**
Client: **Marcolina Design Inc.**
Design Firm: **Marcolina Design**
Designers: **Dan Marcolina, Matt Peacock,**
Quinn Richardson, Mike Lingle
3-D Animator: **Matt Peacock**
Voiceover: **Dan Marcolina**
Programmers: **Quinn Richardson, Mike Lingle**
Authoring Program: **Macromedia Director**
Platform: **Mac**

Marcolina Design's portfolio stands out with its use of a beautifully rendered collage for its contents screen. The piece is rich with interactive opportunities, and rewards the user's curiosity with beauty, whimsy and technical excellence.

Marcolina uses pieces of the illustration—such as the fingers—as buttons that provide either fun tangents or navigational function. Each finger, as well as the moth, takes the user to a different video sequence or an interesting screen effect. Three buttons on the lower-right side of the interface are rollovers that animate when clicked on, and reveal video sequences or even more buttons to explore.

Along with interesting buttons and video, the design includes unique touches: video displayed on the awards cup; the graphics window stretches for viewing portfolio pieces; and voiceovers that play only when the mouse button is held down over the mouth icon.

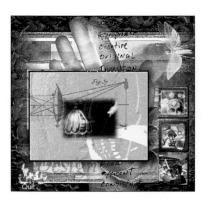

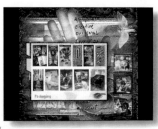

Project: **A Postcard from Hollywood**
Client: **Ginza Graphic Gallery**
Design Firm: **Rhythm & Hues Studios Inc.**
Executive Producer: **John Hughes**
Designers: **Tex Kadonaga, Miles Lightwood**
Director/Illustrator: **Tex Kadonaga**
Programmer: **Miles Lightwood**
Producer: **Jean Tom**
Composer/Sound Designer: **Jay Redd**
Authoring Program: **Macromedia Director**
Platform: **Mac**

Rhythm & Hues Studios' portfolio lives up to its reputation for producing some of the industry's most creative animations and visual effects. Designed as a catalog of selected works from the firm's 1995 Tokyo exhibition at Ginza Graphics Gallery, the portfolio contains video samples of award-winning pieces, demonstrations of computer graphics processes, and a look at the Rhythm & Hues team.

The opening background showcases one of the studio's most popular commercials—the Coca-Cola polar bear series—using initial pencil renderings for the design. Though the interface is basic in its structure and uses simple navigation and easily identified buttons, elements such as the four rotating contents buttons add a distinctive look and feel to the interface, as do the coloring and architectural design elements used on all of the background screens.

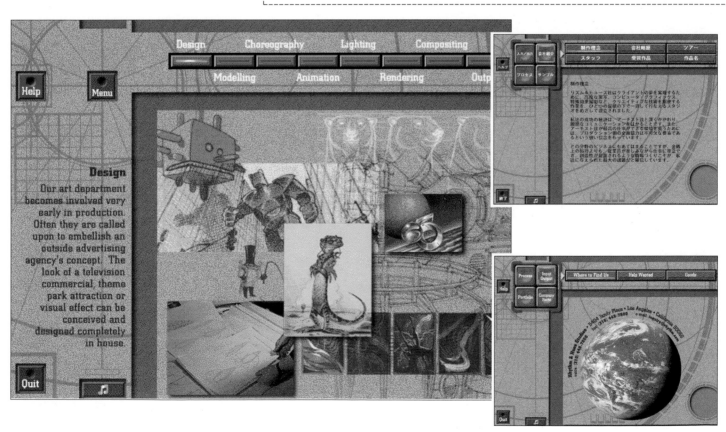

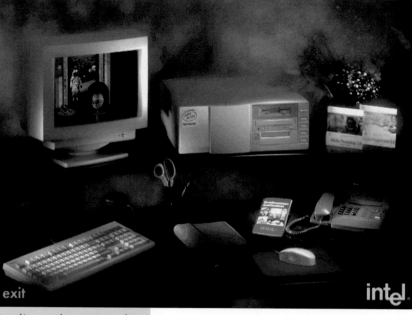

Making History with the Intel Pentium® Pro Processor uses an interface based on the metaphor of the home and office desktop workstation. Certain objects on the desk such as the monitor, computer, keyboard, video phone, and organizer serve as buttons that display information when clicked. These active items are illuminated to distinguish them from non-active items such as the pencil holder, which appear in shadow. This simple interface projects what Intel sees as Pentium's worry-free, no-hassle reputation, immediately understandable by most users.

The organizer is an example of creative minimalism, where a simple pencil sketch of a photograph transforms into a rotoscoped video presentation. Pencil sketches of video control buttons cleverly do the job of conventional buttons.

By providing no text cues except the "exit" button, this interface simulates a real workstation environment and encourages exploration of visual elements.

Project: *Making History with the Intel Pentium® Pro Processor*
Client: **Intel Corporation**
Design Firm: **Lightspeed Interactive**
Designers: **Ian Atchison, Jeanine Panek**
Programmer: **Kevin Flores**
Writer: **Ira Ruskin**
Digital AV: **Shawn Nash**
Video: **Breene Kerr Productions**
Authoring Program: **Macromedia Director**
Platform: **Mac/Windows**

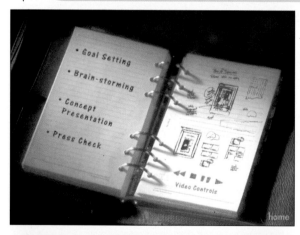

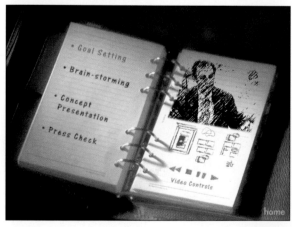

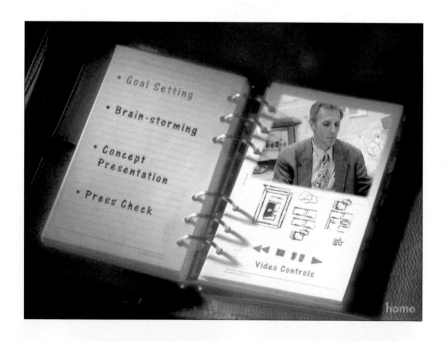

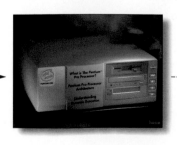

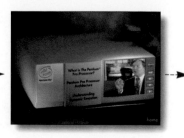

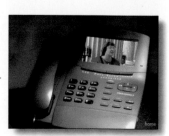

Musician Cleto Escobedo's ethnic background was kept in mind when the designers created both Spanish and English interfaces to navigate this interactive publicity presentation.

To convey the feeling of music, the designers integrate buttons, text and video into music-oriented elements. Saxophone keys on the main menu screen are rollover hotspots that, when clicked, sound a musical note and then take the user to another area of the interactive. Text is set on the right-hand page of a songbook, and a video interview is artfully integrated into a glass of wine. One of Cleto's music videos plays in a rendered 3-D window. Both videos can be viewed in either English or Spanish.

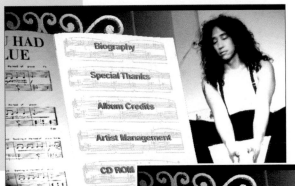

Project: **Cleto Escobedo Interactive Press Kit**
Client: **Virgin Records**
Design Firm: **Tuesday Group Inc.**
Designer: **Richard Parr**
Illustrators: **Steven Mausolf, Nancy Brindley**
Programmer: **Scott Seward**
Authoring Program: **Macromedia Director**
Platform: **Mac/Windows hybrid**

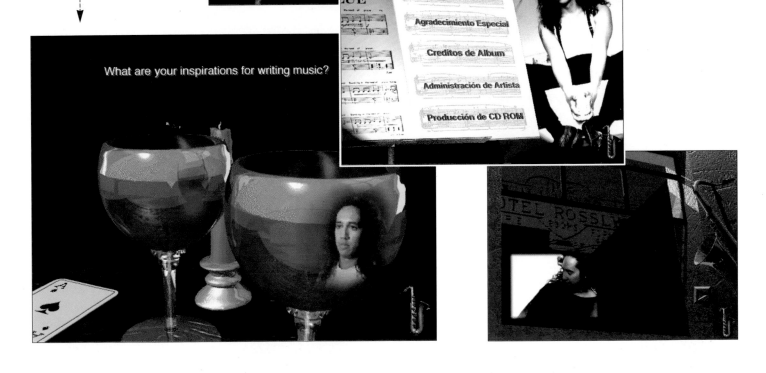

What are your inspirations for writing music?

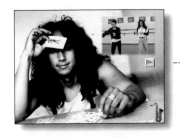

Passage to Vietnam from Rick Smolan (who also authored *From Alice to Ocean*) is perhaps the most intelligent and beautifully designed CD-ROM. A culmination of eighteen months of work by seventy photographers, this award-winning CD-ROM shows an intimate portrait of the people, culture and country of contemporary Vietnam in its more than four hundred photographs. Accompanying the photographs are video sessions with photographers; video and audio clips that explain how and why certain photos were taken; and visits to virtual galleries that acquaint you in detail with four photographers' work.

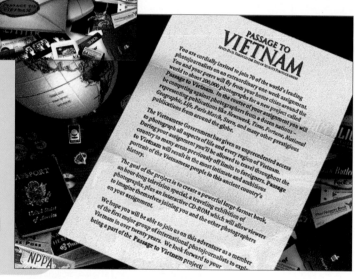

The interface makes use of ad•hoc interactive's "Quebe," a cube-shaped icon that rotates with mouse clicks, which resides in the lower right corner of the screen. Each side has a function that carries the user to different topics, a map, the help screen, or more tools.

During the exploration of *Passage to Vietnam*, the Quebe opens to reveal different items such as a formal invitation for the user to enter a virtual gallery of photographs. At one point Rick Smolan, the project's creator, appears from the top of the Quebe to explain the navigational aspects of the Quebe and the CD-ROM s interface.

In all aspects of the interface, the designers find ways to capture the user's attention, from beautiful photography to a clever video sequence of the publisher walking out onto a precarious monkey bridge to introduce the next topic.

DREAMS OF A
GENTLE LAND
by Pico Iyer

Like most tropical countries, Vietnam gets up with the light, and one of the greatest pleasures you can find there is to go outside at six in the morning and see the whole town out stretching its limbs, playing badminton or soccer in the streets, ghosting its way through *tai chi* motions.

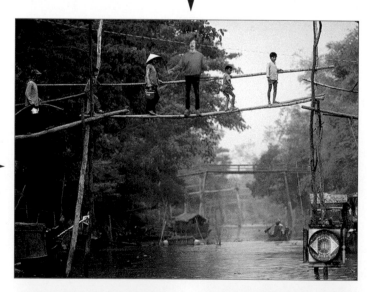

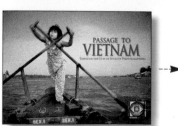

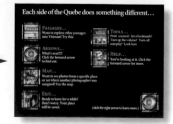

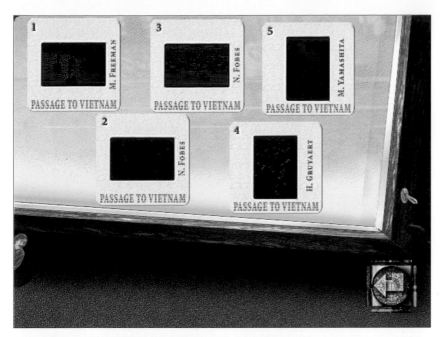

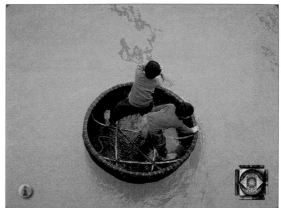

Project: **Passage to Vietnam**
Client: **Against All Odds Productions**
Design Firm: **ad•hoc Interactive Inc.**
Designers: **Aaron Singer, Megan Wheeler**
Illustrator: **Megan Wheeler**
Photographers: **70 international photographers**
Programmer: **Shawn McKee**
Authoring Program: **Macromedia Director**
Platform: **Mac/Windows/Windows 95**

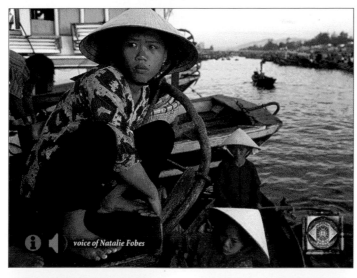

voice of Natalie Fobes

Dick Swanson

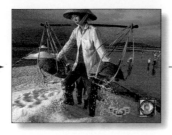

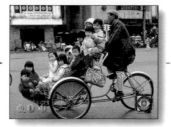

URL: http://www.teknoland.es/

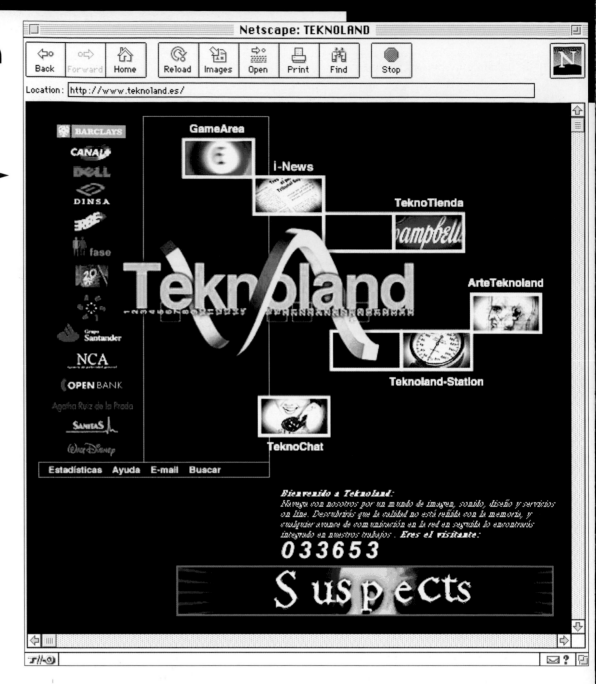

Location: http://www.teknoland.es/

SELF-PROMOTION

The Teknoland site showcases the artistic and technical design and programming skills of the Spanish design firm Teknoland. The home page allows access to numerous areas, such as game and chat areas, and contains links to Teknoland's clients.

The site displays a high degree of technical expertise, implementing chat rooms, online gaming, and Shockwave streaming audio for an online radio station.

Its "Suspects" game features 95 actors and over 2,500 images. Viewers get to play the game via a Myst-like interface. Although the site is predominantly Spanish, the designers anticipate an English version of "Suspects" to increase accessibility.

The finished look of the site is accomplished by the use of dark backgrounds, clean lines, and sharp imagery. The Teknoland spiral logo used as a header element unifies the site.

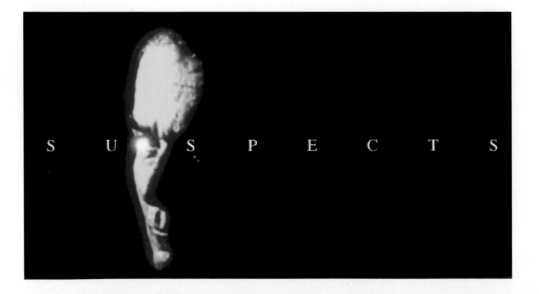

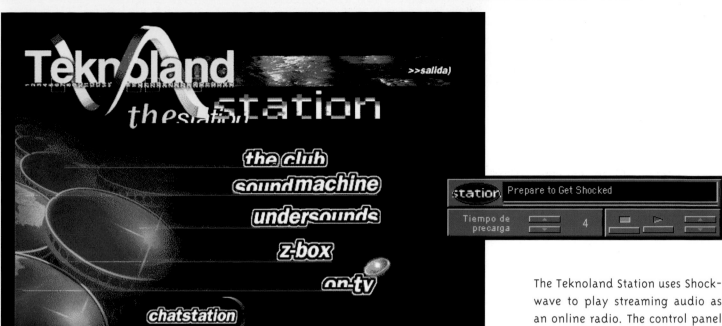

The Teknoland Station uses Shockwave to play streaming audio as an online radio. The control panel (above) plays different songs.

Project: **Teknoland**
Design Firm: **Teknoland**
Art Director: **David L. Cantolla**
Programmers: **Colman Lopez,
Jesus Suarez, Rafael Sarmiento,
Cesar M. Ibanez**
Features: **GIF89a animation,
Shockwave, streaming audio**

Events That Changed The World uses an interface that displays unparalleled creativity. From the opening screen to the end credits, the designers achieve a uniform level of artistic and technical excellence. The designers skillfully blend various elements of the interface to create a memorable and fulfilling insight into historical events.

To create a clean and uncluttered interface, the designers give users discretion over which of the main navigational tools they wish to have displayed. A marble-textured bar along the side of the screen allows the users to hide or reveal buttons with a single click. Shadows and highlights are used throughout the interface to create a sense of drama and depth, while illustrations used for backgrounds and frames look as if they have been projected onto a 3-D surface.

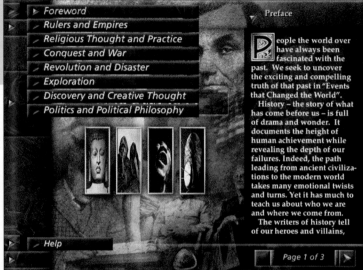

Project: *Events That Changed the World*
Design Firm: **ICE**
Designers: **Pete O'Neil, Simone Paradisi, Sean Patrick, Steven Wicks**
Illustrator: **Robert Ingpen**
Producer: **Michael Plexman**
Programmers: **Darryl Gold, Pete O'Neil, Steven Wicks**
Authoring Program: **Macromedia Director**
Platform: **Mac/Windows**

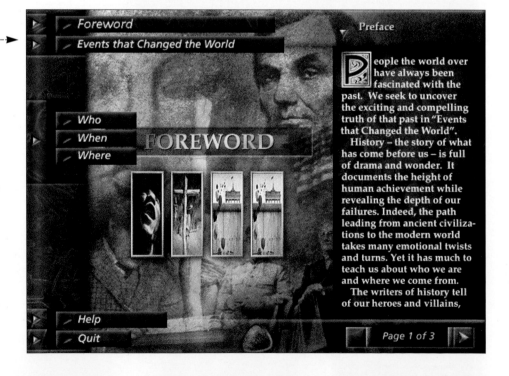

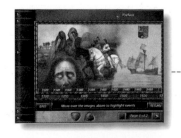

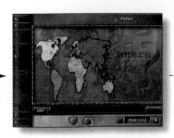

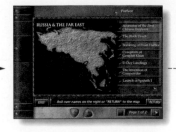

a-b
c
d-g
h-j
k-l
m-n
p-r
s-z

Alexander I, Tsar
Amherst, Jeffrey
Appia, Louis
Aquinas, Thomas
Aristotle
Asoka
Augustine, Saint
Augustus, King Philip II
Aztecs
Bagration, Prince
Becquerel, Henri
Bedford, Duke of
Bindusara
Bohr, Niels
Bolivar, Simon
Bonaparte, Napoleon (Battle of Trafalgar)
Bonaparte, Napoleon (Fall of the Bastille)

who?

EXIT Click on the name window or the alphabet

Page 1 of 3

300 BC 1000 AD 1300-1400 AD

0000 AD 1200 AD 150

-1000 0000 1000 1100 1200 1300 14

EXIT You are at the main menu of the When navigator

Page 1 of 2

URL: http://www.iliad.com/gravicadesign/

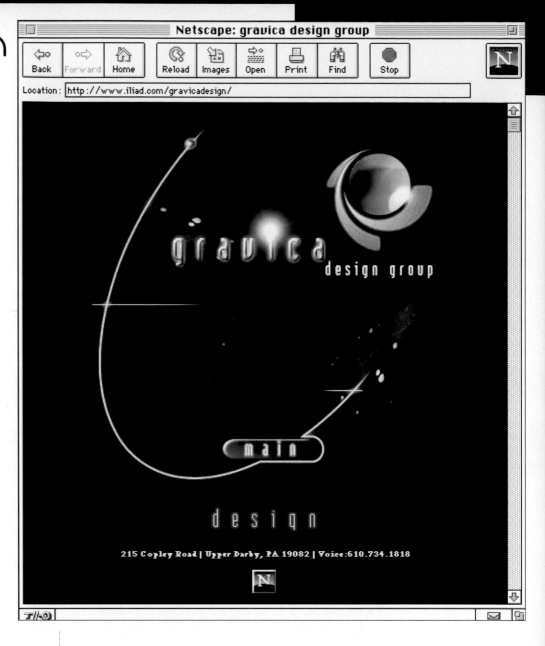

Location: http://www.iliad.com/gravicadesign/

SELF-PROMOTION

The Gravica Website demonstrates an ability to incorporate rich photo collage, graphics, and typography while keeping download times reasonable with page file sizes under 40k.

The black background sharply contrasts with the colorful and luminescent images.

Because the designers dislike the way HTML text looks when used on a Web page, they decided to make the majority of their text bit-mapped artwork, admitting that this wouldn't work well for some clients because it increases download time.

A GIF89a animation cycles through the company's motto: "Transcend the mind with captivating design." The same luminescent typography is used on sub-pages to indicate active areas.

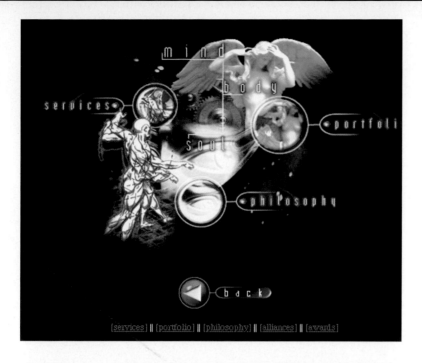

[services] || [portfolio] || [philosophy] || [alliances] || [awards]

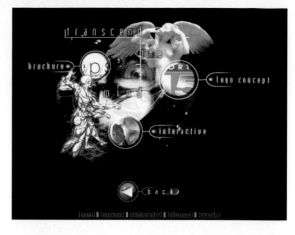

[main] || [services] || [philosophy] || [alliances] || [awards]

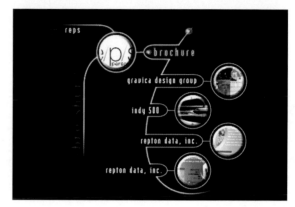

The planetary orbital ellipse from the home page is repeated as a navigation element, replacing the more commonly used rectangular navigation bars.

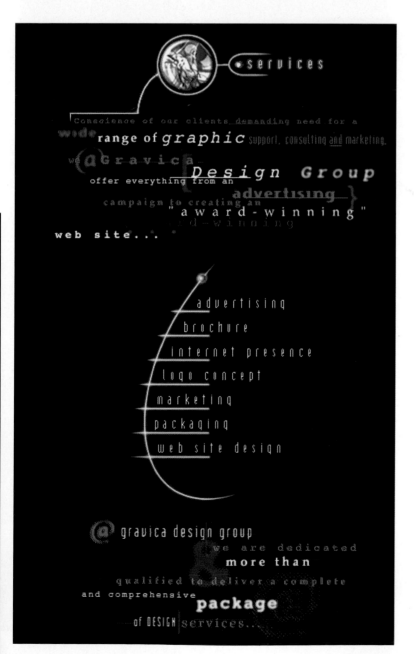

Project: **Gravica Portfolio**
Design Firm: **Gravica Design Group**
Designers: **Michael McDonald, Charles Molloy**
Programmers: **Michael McDonald, Seth I. Rich**

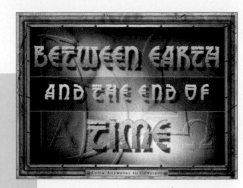

Between Earth and The End of Time is a journey into the worlds of painter/illustrator Rodney Matthews, a journey where users examine Matthews' painting techniques and creative processes while viewing interviews with the artist, and browsing through hundreds of pieces of fantasy art. Incorporated into the interface navigation is a scavenger hunt game where the user collects words hidden throughout the CD-ROM, which are later used to solve a puzzle.

The main interface, a three-dimensional image of layered marble columns and entryways, is complemented by the use of light and shadow to create depth, adding to the overall feeling of entering Rodney's world of fantasy. The columns are used not only to frame the interface and the videos, but also to incorporate a number of navigational buttons.

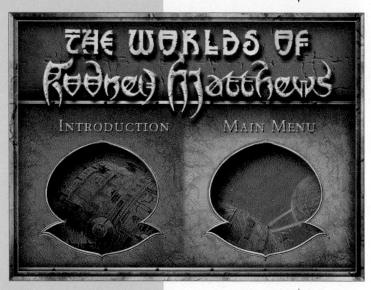

Another innovative technique that draws the user into the content is shown below in the first four panels. This interface allows the user to create a collage-like painting by choosing pieces of Matthews' art and then layering them on top of each other. This same technique is repeated in the "Build Your Own Logo" section of the interactive.

Two other items that add to the richness of the interface are the ability to view video in 8-bit or 16-bit format, and short trivia games that are incorporated into the different galleries of his paintings.

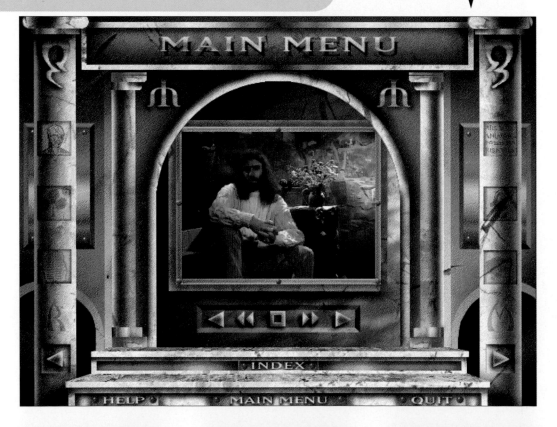

THE QUEST FOR TANELORN

DRAG A WORD TILE ONTO THE COMPOSING STICK AND COMPLETE THE SEVEN WORD PHRASE TO END YOUR QUEST. YOUR REWARD AWAITS YOU.

ASSEMBLING AN ILLUSTRATION

MAIN MENU

INDEX

THE MOCK TURTLE'S STORY

BASICS OF COMPOSITION

Chase the Dragon and its companion piece, Sanctuary, are classic examples of how work can be adapted for different uses.

Chase the Dragon's square format was dictated by its use as a cover for a record by the band Magnum.

Project: *Between Earth and the End of Time*
Design Firm: **ICE**
Designer: **Steve Beinicke**
Illustrator: **Rodney Matthews**
Programmer: **Margaret Beck**
Authoring Program: **Macromedia Director**
Platform: **Mac/MPC**

Presto Studios' home page designers chose to keep the interface clean and uncluttered by eschewing traditional buttons, instead using colorful, rendered 3-D titles to link to associated pages. The linked pages continue the title style as headings at the top of each page, with a subtle change to each that includes a smoke effect billowing around them.

Tiled background images of Presto Studios' logo and name reinforce a design that keeps the company's identity visible at all times, and preliminary line drawings from *Buried in Time* (the company's most successful game) are tiled as a background on the "Available Titles" page.

Though the Website is primarily self-promotional, Presto Studios knows that, in order to attract return visitors, it must offer added attractions. The "Destinations" page fulfills this by providing viewers links to gaming magazines and related Websites.

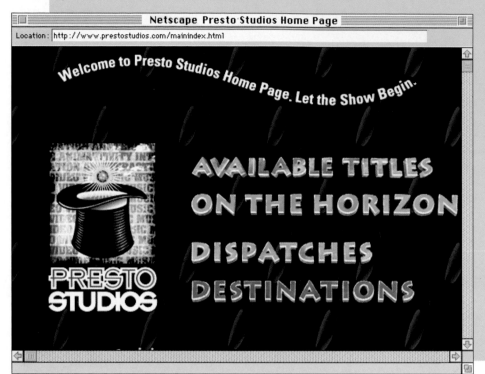

Project: **Presto Studios Website**
Design Firm: **Presto Studios**
Designers: **Frank Vitale, Eric Fernandes**
Programmers: **Eric Fernandes, Prakash Kirdalani**
Authoring Program: **HTML**
Platform: **Browser Related**
URL: **http://www.prestostudios.com**

Introduction

When we look at a stranger's face, we can sometimes tell what sort of person he or she is—outgoing, happy, depressed, etc. We can't tell what passions or hates that individual might have, but through the medium of language (if we both speak the same language) we can generally start a utilitarian relationship and at least find out the time of day; sometimes we can reach a deeper understanding and be moved by another individual. When we look at a computer screen, we are looking at the face of an electronic tool; how that face looks to us depends on the sensibilities of another human being—a designer or a team of designers. Some are more successful than others in creating an engaging and usable interface for their game, Web site, portfolio, kiosk, advertisement, music video, automatic teller machine, etc. (The types of interactions a person has with computers are probably as varied as people are.) This book features a sampling of interface successes.

The interface designs featured here all are examples of good design plus great interfaces and sensible use of technology—some of them seem comfortable and intuitive, while others are a little more opaque, where getting to know the interface is the whole point. Although they range from small floppy disk portfolios and Web sites to CD-ROM games and mammoth museum kiosk installations, they all share these qualities: very high production values in terms of art and design—there are no misplaced pixels; there is always an intuitive access point for new users, even in a complex project, and users are given navigation flexibility to move forward, back and out easily; and finally, technology is used judiciously and not gratuitously.

The interfaces featured here should be considered starting points for the interfaces of the future as new technology, more informed users, and better synthesis of designers with programmers will yield subtler and more delightful interfaces. Perhaps interface styles will become as idiosyncratic and recognizable as designers and artists presently are—as Van Gogh is recognized by his brush stroke and use of color, some fine designer in the future will be recognized by her unique style of engaging the user and giving him more than just the time of day. The future is wide open....

—Daniel Donnelly
Interactivist Designs
www.inyourface.com

**Space Jam
Interactive Kiosk**

Animation Studio:
**CBOmultimedia, div.
Cimarron/Bacon/O'Brien**
Client/Agency: **Warner
Brothers, Denise Bradley,
Bob Bejan**
Creative Director: **Jill Taffet**
Supervisor/Animator:
Robert Vega
Director: **Jill Taffet**
Director of Production:
John Peterson
Programmer: **Peter Wolf**
Digital Artist: **Sabrina Soriano**
Executive Producer:
Robert J. Farina
Software Used: **Radius Video
Vision, MacroMedia Director,
Adobe After Effects and
Photoshop**
Hardware Used: **FWB Jack
Hammer, FWB Array,
MicroTouch Touch Screen,
Power Macintosh**

The Space Jam Interactive
Kiosk was created to promote
the new Warner Bros. movie
Space Jam prior to its release.
The kiosk interface is a wild
and exciting scene of animated
basketballs that fly out and
bounce at you when selected.
The kiosks previews all the
aspects of the movie showing
clips, pencil tests, story and
merchandise.

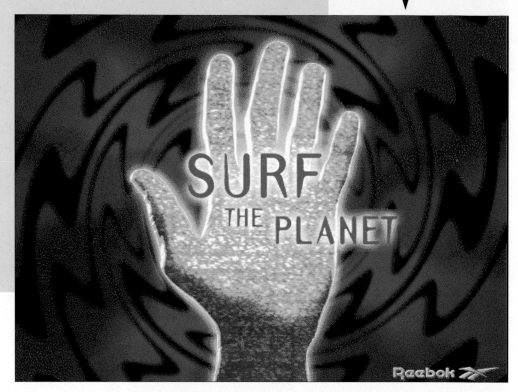

Reebok 100 was developed as a traveling touch-screen exhibit for Reebok's 100th anniversary. The exhibit traveled to athletic events in ten different countries, including Japan and Chile. Designed to display and promote Reebok products to young adults, the kiosk has a distinctly raucous, MTV-like feel characterized by garish colors, hyperactive motion effects and contemporary fonts. To track demographics, users are asked to name their gender, and then select their age group, which offers a smart quip.

Users are encouraged to browse through the kiosk's content by the offer of a product coupon, which is issued by the kiosk when users touch three hidden items, found in various sub-sections. Not a challenging task, this requirement extends the length of time users spend viewing the content.

After volunteering demographic information, users are given options to explore nearly all of Reebok's current product line by touching one of sixteen areas of interest. After making this selection, users can view pieces of nearly 800MB of digitized animation and video.

Project: *Reebok 100*
Client: **Reebok International, Ltd.**
Design Firm: **Planet Interactive**
Designers: **Joan DeCollibus, Cliff Stoltze, Alyson Schultz**
Illustrator: **Mark Shaw**
Programmers: **Lisa Sirois, Rich Martin, Michel Milano**
Authoring Program: **Macromedia Director**
Platform: **Windows PC**

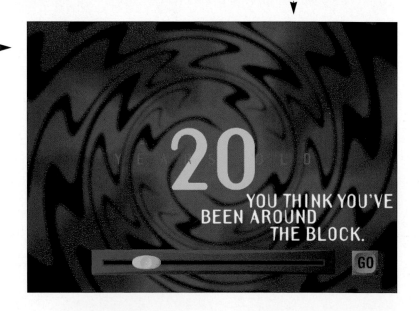

PICK YOUR INTEREST

BOKS

WELCOME
20 YEAR-OLD
FEMALE WITH AN INTEREST IN
OUTDOOR

FIND 3
HIDDEN THINGS
AND RECEIVE AN
INSTACOUPON

just think is an interactive political/cultural magazine published on CD-ROM. The second issue, shown here, reflects the high quality of design and illustration that users expect while exploring the magazine.

The contents screen gives users easy access to the articles featured in the issue with text and icons representing the articles. As in traditional magazine design, each article is given a different look through the use of illustration, video, and photography.

One of the most unique features in *just think*'s design is the "Quebe", a 3-D navigational cube that is used in all of ad•hoc s interfaces. This navigational device spins across the screen from left to right, and disappears in reverse once a side of the Quebe has been selected. The Quebe offers access to the contents, help, tools, or exit buttons when it is rotated top to bottom, or left to right.

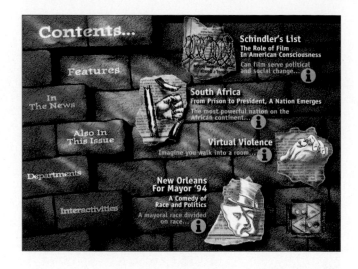

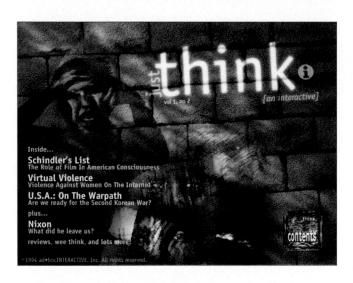

Project: *just think (an interactive)*
Design Firm: **ad•hoc Interactive, Inc.**
Designers: **Megan Wheeler, Aaron Singer, Shawn McKee**
Illustrators: **Megan Wheeler, Ray Ferro, Craig Brown**
Programmer: **Shawn McKee**
Authoring Program: **Macromedia Director**
Platform: **Mac/Windows**

 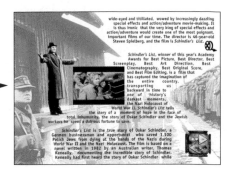

 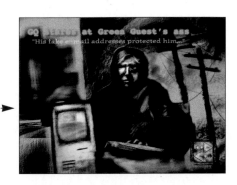

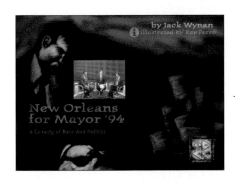 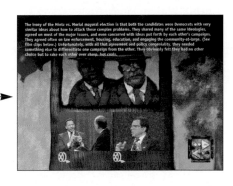

 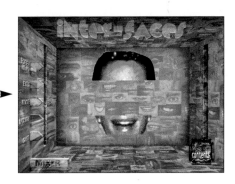

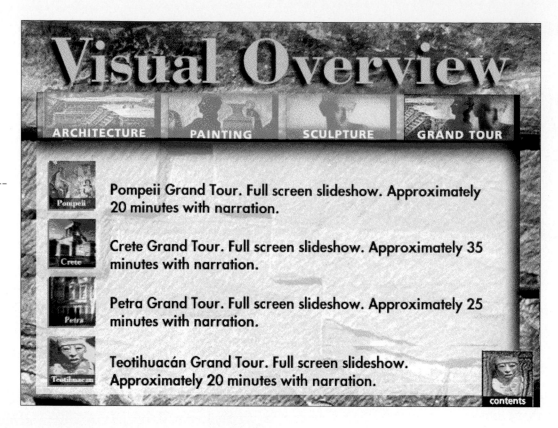

Visual Overview

ARCHITECTURE PAINTING SCULPTURE GRAND TOUR

Pompeii Grand Tour. Full screen slideshow. Approximately 20 minutes with narration.

Crete Grand Tour. Full screen slideshow. Approximately 35 minutes with narration.

Petra Grand Tour. Full screen slideshow. Approximately 25 minutes with narration.

Teotihuacán Grand Tour. Full screen slideshow. Approximately 20 minutes with narration.

contents

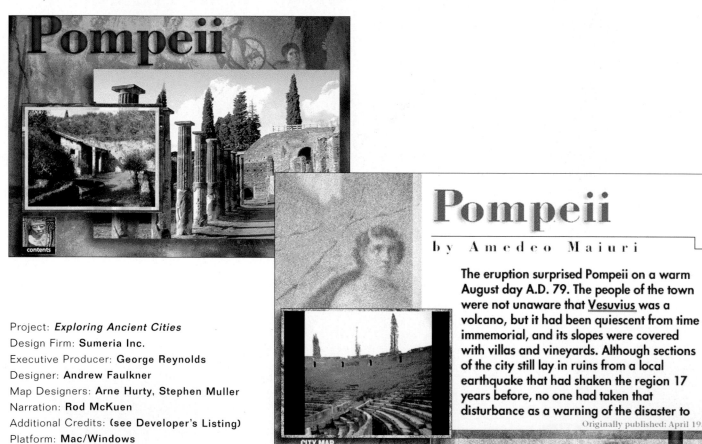

Pompeii

Pompeii
by Amedeo Maiuri

The eruption surprised Pompeii on a warm August day A.D. 79. The people of the town were not unaware that <u>Vesuvius</u> was a volcano, but it had been quiescent from time immemorial, and its slopes were covered with villas and vineyards. Although sections of the city still lay in ruins from a local earthquake that had shaken the region 17 years before, no one had taken that disturbance as a warning of the disaster to

Originally published: April 1958

CITY MAP

contents

Project: *Exploring Ancient Cities*
Design Firm: **Sumeria Inc.**
Executive Producer: **George Reynolds**
Designer: **Andrew Faulkner**
Map Designers: **Arne Hurty, Stephen Muller**
Narration: **Rod McKuen**
Additional Credits: **(see Developer's Listing)**
Platform: **Mac/Windows**

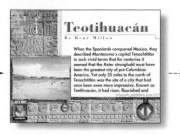

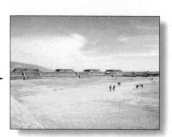

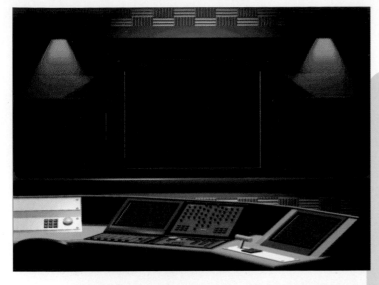

Video Producer is an award-winning course that teaches the creation of clean, professional video. Using an interface that resembles a live-video production suite, users train in various aspects of video production: camera usage, lighting, audio, editing and the process of video production.

The navigation of the content is simple, with icon-based buttons used along with text treatments to allow for ease of recognition. But what pulls the design together and makes it a useful source for interactive training is the extensive use of narration and video for all of the exercises.

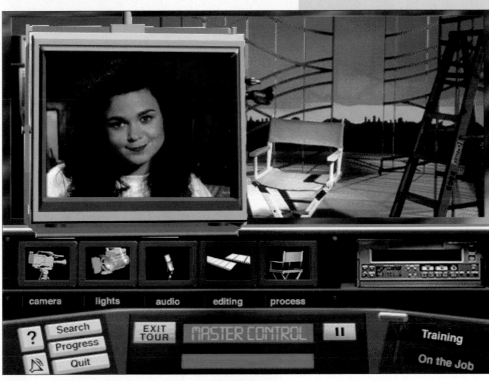

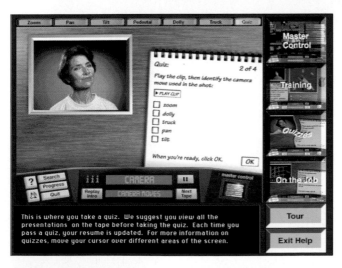

Project: **Video Producer**
Client: **Wadsworth Publishing**
Design Firm: **Cooperative Media Group**
Interface Designer: **Jeff Caton**
Instructional Designers: **Jeff Caton, Jeff Katzman, Jeff Larsen, Chris Pitts**
Illustrators: **Jeff Caton, Mark Straka, John Beebe**
Programmers: **Jeff Katzman, Rob Danbin**
Photographers: **Ken Smith, Jeff Caton**
Authoring Program: **Authorware**
Platform: **Mac/Windows**
Production Date: **Mac/October 1995, PC/August 1996**

 → → →

EDUCATIONAL/REFERENCE

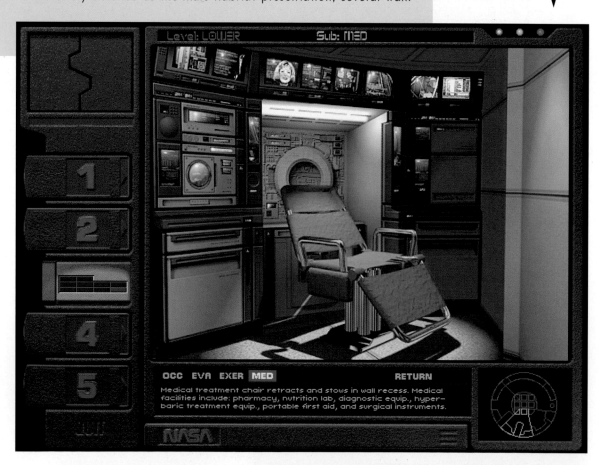

Marsbook CD, produced by Human Code in 1993 for NASA, is a virtual guide to NASA's Initial Planned Mars Habitat. It was created using an early version of what was then MacroMind Director and used the first release of QuickTime—as such, it represents an immense effort of 3-D rendering and data organization. Remarkably, this presentation is satisfying even though there is no audio track. The intricate detail of the rendering, the ability to zoom in and examine visual detail, and the precise engineering notes are accessed quickly, quietly and efficiently, seemingly in the silence of space.

Five "LevelKeys" allow viewers to examine both the interior and exterior of each level in the station in several ways: as wireframe floor plans, as fully rendered diagrams showing construction dimensions and mechanical cutaways, or as interactive video walkthroughs. The viewer controls the direction and speed of walkthroughs using the small Navigation Window in the upper left corner. Clicking on an object in the Navigation Window interrupts the tour and displays a detailed 24-bit color image of the object in the large display window, and descriptive text in the information window below. When viewing exterior images of the habitat, the Navigation Window displays a thumbnail image that rotates in any direction by clicking and dragging. The rotated image is then displayed in large format on the main viewscreen.

Additionally, a lunar module is accessible for viewing via the NASA control panel under the text box. Though not as obsessively detailed as the Mars Habitat presentation, several walkthrough presentations are available.

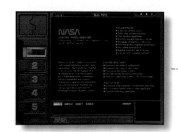 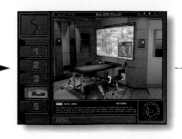 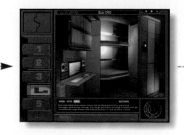 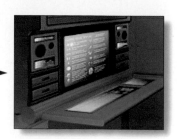

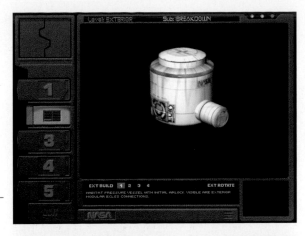

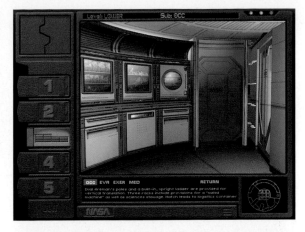

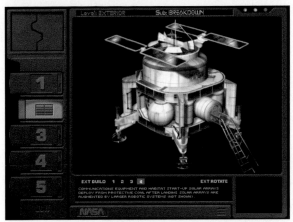

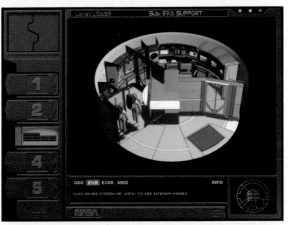

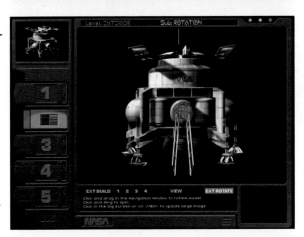

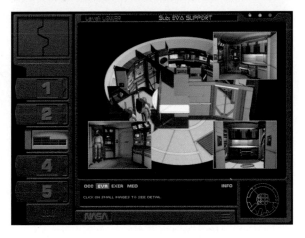

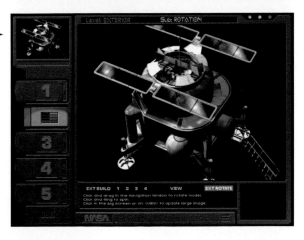

Project: *Marsbook CD*
Client: **NASA**
Design Firm: **Human Code, Inc. and Design Edge Media Integration**
Designers: **Chipp Walters, Lindsay Gupton, Reed McCullough, Nathan Moore, David Gutierrez**
Programmer: **Gary Gattis**
Authoring Programs: **SuperCard, Macromind Director**
Platform: **Mac**

Number Nine's *Are You Satisfied* kiosk, designed by Planet Interactive on CD-ROM, hawks PC and Mac graphics accelerator cards by illustrating for consumers what an accelerator card does and why they need one.

Number Nine's print advertising campaign includes lists of nine reasons to buy its products. To complement this campaign, Planet Interactive created multiple-choice question-and-answer screens. When questions are answered correctly, a creative animated sequence displays video, rotating and moving text treatments.

The kiosk uses a video loop to attract passers-by, continuing until user input starts the interactive part of the presentation. All pieces are complemented with original music and voiceovers.

Because they are displayed in superstore settings, these kiosks needed to be informative, interactive and engaging to set themselves apart from the plethora of existing self-running demos.

Project: *Are You Satisfied?*
Client: **Number Nine Inc.**
Design Firm: **Planet Interactive**
Designers: **Joan DeCollibus, Michel Milano, Brian Paik**
Programmers: **Michel Milano, Rich Martin**
Photographer: **John Rae**
Authoring Program: **Macromedia Director**
Platform: **Windows**

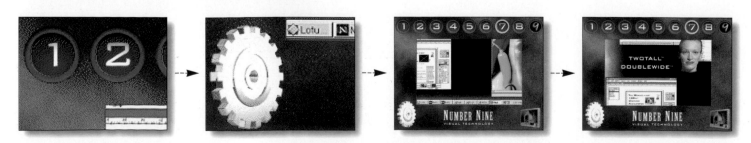

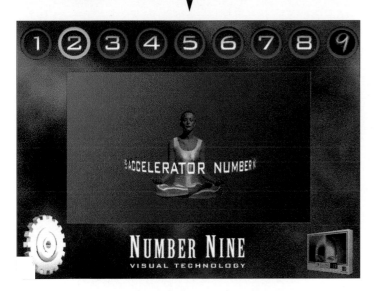

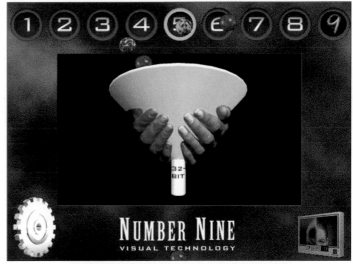

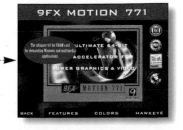

Civil Rights:
then + now

CD-ROM graphics
Animation Studio: **CBOmultimedia,**
div. Cimarron/Bacon/O'Brien
Client/Agency: **Castle Rock**
Entertainment, Tammy Glover,
Producer New Media
Creative Director: **Jill Taffet**
Supervisors/Animators: **John**
Peterson, Peter Wolf, Larry Wilcox
Technical Director: **John Peterson**
Director: **Jill Taffet**
Digital Artists: **Sabrian Soriano,**
Ryan Anista, Elika, Larry Wilcox
Programmer: **Peter Wolf**
Production Manager: **Amy Mattingly**
Executive Producer:
Robert J. Farina
Software Used: **Macromedia**
Director, Adobe After Effects,
Premiere, and Photoshop, Radius
Video Vision
Hardware Use: **Power Macintosh**

This is a companion CD-ROM to
Rob Reiner's film, *Ghosts of
Mississippi.* "Civil Rights: then +
now" explores the history of the
Civil Rights movement. Whoopi
Goldberg acts as host in the
hip/hop, urban, virtual world,
and the CD-ROM is both enter-
taining and educational.

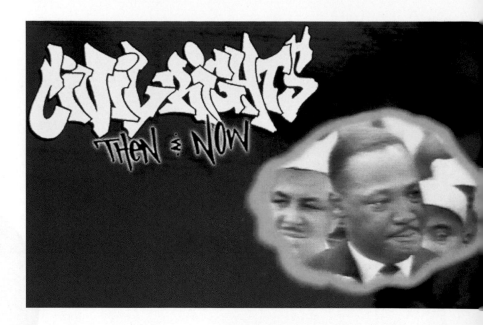

**Internet Explorer
animated logo**

Animation Studio:
Dawson 3-D, Inc.
Character Creator/Designer:
Henk Dawson
Supervisor/Animator:
Henk Dawson
Art Director:
Jeff Boettcher (Microsoft)
Project Coordinator:
Kristen Dawson
Software Used:
**auto•des•sys Inc. form•Z,
ElectricImage Animation
System,
Adobe Photoshop**
Hardware Used:
Macintosh

The goal of this animation was to create a simple and eye-catching icon that works well on-line. The end result was a swish with a traveling light going through the big "e." Thus, the "e" was easy to identify, and the traveling light provided viewer intrigue and staying power.

©Microsoft

Ketchum Kitchen's Website showcases a division of Ketchum Communications that specializes in public relations and advertising efforts for food-related clients. This home page from Red Dot Interactive is a food lover's paradise: a working test kitchen that offers a library of easy-to-make recipes, and a treasure trove of useful cooking tips.

Visitors to the site are greeted by bright graphics that offer easy access to the three main areas of the site. Red Dot has created a site that not only promotes Ketchum, but also provides real value for Web users.

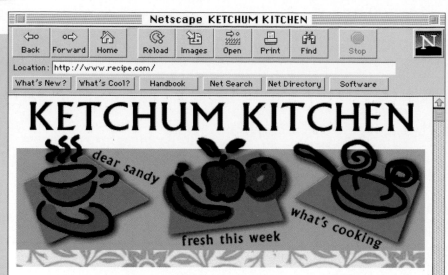

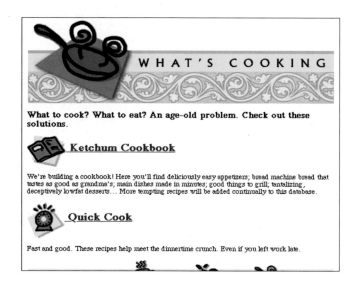

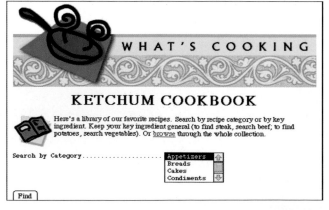

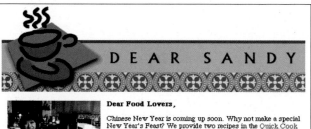

Project: **Ketchum Kitchen**
Client: **Ketchum Communications**
Design Firm: **Red Dot Interactive**
Creative Director: **Judith Banning**
Authoring Program: **HTML**
Platform: **Browser Related**
URL: **http://www.recipe.com**

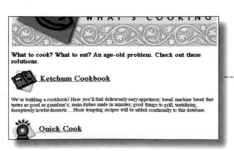

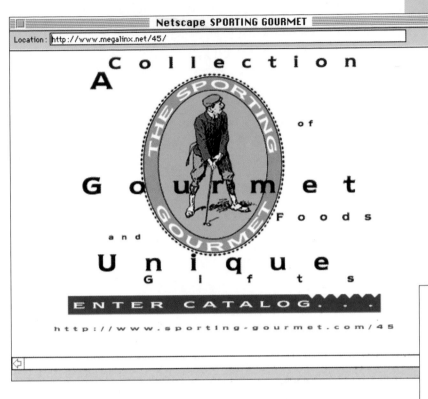

Sporting Gourmet's online catalog posed a challenge to CopperLeaf Design Studio: the design firm needed to present the catalog in a way that would be simple to navigate and would display the products, without cluttering the pages or burying the products under too many links.

CopperLeaf used a contemporary treatment on the home page, and continued the style throughout the catalog, using anti-aliased text and bullets from a drawing program, rather than rely on the browser's bitmapped type. To keep the design clean the studio used longer vertical pages that load slowly, but allow much easier navigation.

Project: **Sporting Gourmet Catalog**
Client: **Steve Craver**
Design Firm: **CopperLeaf Design Studio**
Designers: **Steve Shaw, Jason Brua**
Illustrator: **Cathleen Carbery-Shaw**
Programmer: **Steve Shaw**
Photographer: **Lisa Marie Deville**
Authoring Program: **HTML**
Platform: **Browser Related**
URL: http://**www.sporting gourmet.com/45**

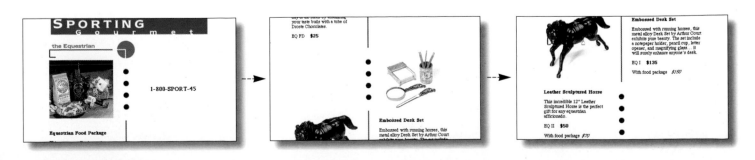

53

Graffito/Active8 leads the field of design firms experimenting with Director animations on their home pages. One of the most important online developments is the release of Macromedia's Shockwave plug-in for Netscape. This software makes it possible for Web designers to place interactive Macromedia Director files or animations into their Web pages, which can be viewed by anyone running Netscape.

Two navigation options are offered for getting to the contents page. Clicking on the "shocked" button takes the viewer to an animated introduction that includes high-quality sound and moving text leading to the contents page. Clicking on the "standard" button offers a direct link to the contents page. The latter option uses less bandwidth and gets the viewer to the contents page more quickly, but the former option is more entertaining.

Incorporating this animated opening into Graffito/Active8's Website gives the company a chance to show visitors and potential clients a more complete picture of their multimedia design capabilities.

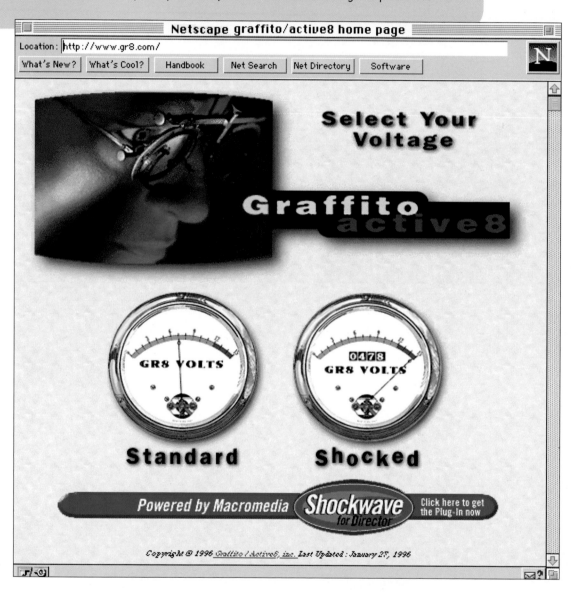

Project: **Graffito/Active8 Website**
Design Firm: **Graffito/Active8**
Designers: **Tim Thompson, Jon Majerik**
Illustrator: **Josh Field**
Programmer: **Jon Majerik**
Photographers: **Ed Whitman, Taran Z, Michael Northrup**
Authoring Program: **HTML**
Platform: **Browser Related**
URL: **http://www.gr8.com**

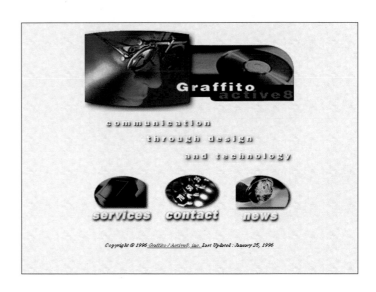

The Emigre type foundry needed a floppy disk-sized promotional piece to distribute over their *Now Serving* bulletin board service and promote the ZeitGuys font. Because the download time needed to be kept as short as possible, bitmapped images created from the font comprise the majority of the brochure.

The introduction opens with an animated type treatment, then segues into a looped slide show of the ZeitGuys font, accompanied by a sound file that loops until the user clicks to go to another screen.

The *ZeitMovie* makes use of minimal interactivity, needing only a "forward" and "backward" button to navigate the main interface.

Once in the main interface, dynamic screen action in the form of constantly shifting images from the font keeps the user engaged. The components of this piece—fonts, sound bites and animated sequences—work well to emphasize the quirky, irreverent nature of the ZeitGuys font.

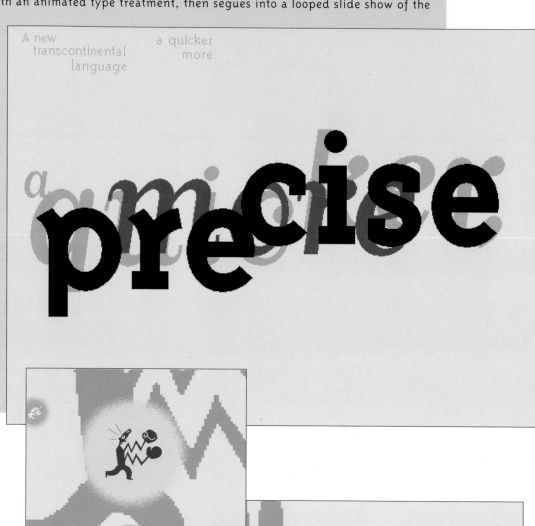

Project: *ZeitMovie*
Client: **Emigre**
Design Firm: **Aufuldish & Warriner**
Designer: **Bob Aufuldish**
Writer: **Mark Bartlett**
Sound: **Scott Pickering, Bob Aufuldish**
Icons: **Eric Donelan, Bob Aufuldish**
Programmer: **Bob Aufuldish**
Authoring Program: **Macromedia Director**
Platform: **Mac**

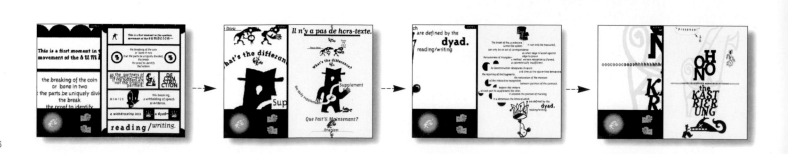

imedia's portfolio beckons users to navigate around a virtual office. The interface comprises 3-D objects such as a note on the door, a telephone, and a printer. Clicking on these objects reveals background information about the company. In a creative display of interactivity, almost all the objects in the office are either functional or entertaining. For instance, clicking on a videotape, floppy disk or CD-ROM activates the relevant playback device complete with lights and sound, which then displays more information about the company. On the whimsical side, clicking on an electrical outlet produces sparks accompanied by crackling. Clicking on the plant changes the cursor from a hand to a watering can.

Cursor transformation is used to signal important information to the user. Instead of offering the user an obvious exit button, the exit option is signaled when the cursor changes from a hand to an open door. This change occurs when the cursor rolls over the large picture window in the office. The virtual environment is also enhanced and softened by the extremely well-crafted lighting effects.

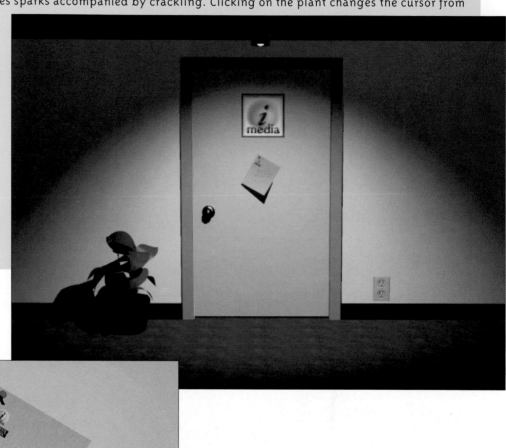

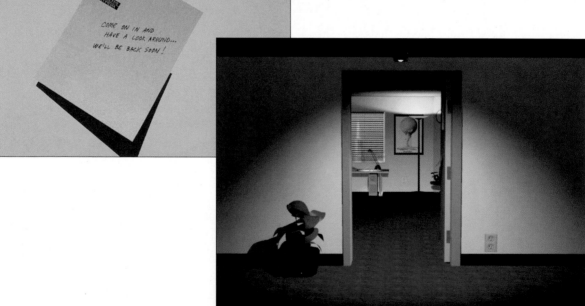

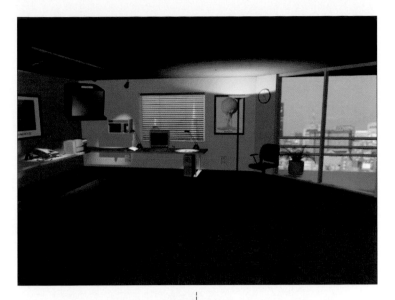

Project: *imedia Studio Tour*
Design Firm: imedia Interactive Multimedia
Designers: **B. Almashie, H. Campos**
Illustrators: **B. Almashie, H. Campos**
Programmers: **B. Almashie, H. Campos**
Authoring Program: **Authorware**
Platform: **Mac/Windows**

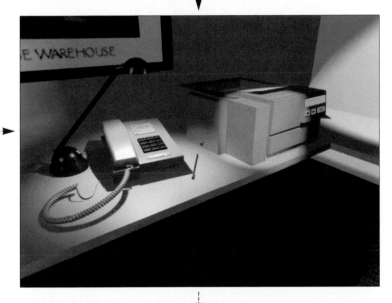

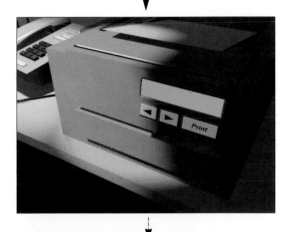

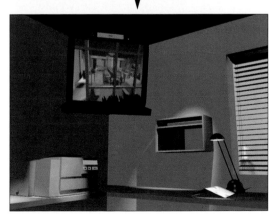

PROMOTIONAL PRESENTATION

Novell's *NetWare 4.1 Multimedia* promotion, designed by Lightspeed Interactive, uses vibrant colors and a futuristic 3-D design to create a dynamic interactive experience. This project pushes the boundaries of the traditional corporate presentation, resulting in a successful sales and marketing tool.

The main menu offers users three areas to navigate, as well as an unobtrusive menu bar placed at the bottom of the screen, accessible at all levels of the interface. One of the most innovative elements of the design is the use of rendered 3-D icons that pop up above the menu bar and spin or rotate when the cursor rolls over a button. A perspective grid for a background surface creates an illusion of depth and distance, adding to an interface that is already characterized by 3-D shapes and images.

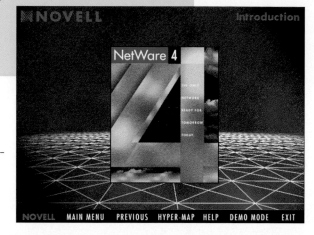

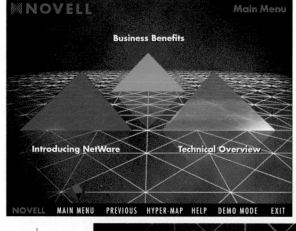

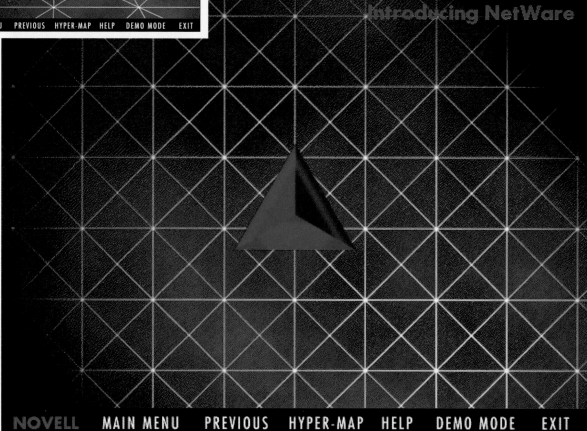

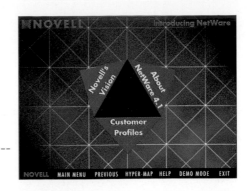

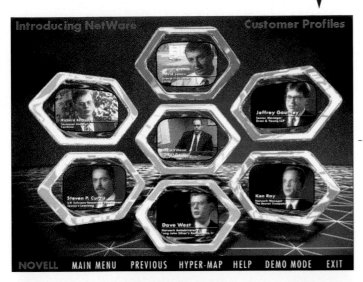

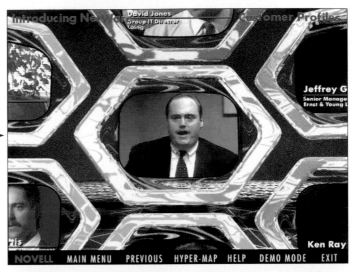

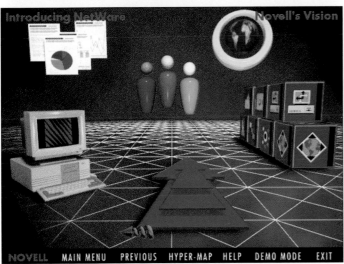

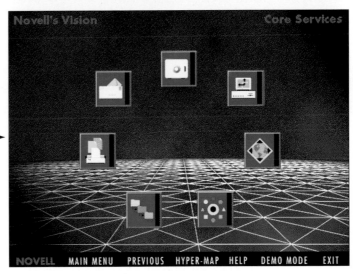

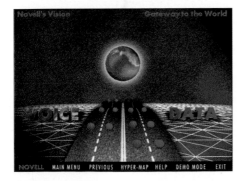

Project: *Novell NetWare 4.1 Multimedia CD-ROM*
Client: **Novell Inc.**
Design Firm: **Lightspeed Interactive, Inc.**
Creative Director: **Kevin Flores**
Designers: **Ian Atchison, Shawn Nash, Jeanine Panek**
Programmer: **Kevin Flores**
Video: **Breene Kerr Productions**
Authoring Program: **Macromedia Director**
Platform: **Mac/Windows**

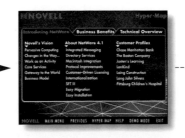

The New Leader: Communication, Cooperation, and Trust dodges the common problem of uninteresting tedium in traditional management training using video or lectures that makes it difficult for learning to take place.

Repurposing the same information in the form of an interactive CD-ROM makes the same material interesting and accessible. *The New Leader's* designer, Lightspeed Interactive, successfully repurposed text and video to create an engaging and comfortable environment in the form of a 3-D Alpine village, a virtual campus for first-level management training. The interiors of the buildings are well-crafted and help to extend the comfortable, engaging learning environment.

Learning sessions take place in several locations: in the café over a cup of coffee, in the library, at the theatre, and on a bench in the village park with a friendly stranger who just happens to be knowledgeable about management training. The vendor at the newsstand is also very helpful about management issues. These friendly and helpful villagers are actually video-taped actors filmed against a blue-screen background, and then incorporated into the rendered village.

Clicking on the palette at the bottom of each screen moves users to one of the four main areas of the village; clicking on unmarked hotspots takes them directly to their destination.

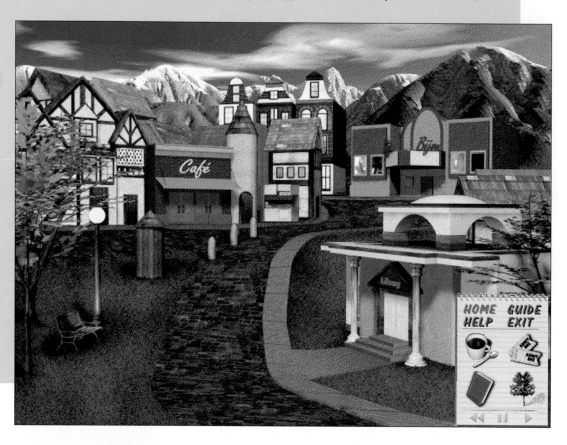

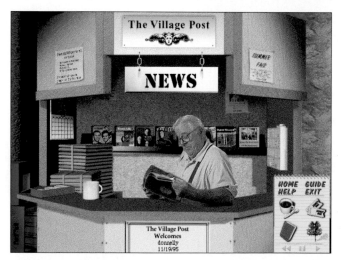

Project: *The New Leader: Communication, Cooperation & Trust*
Client: **Athena Interactive Inc.**
Design Firm: **Lightspeed Interactive Inc.**
Designers: **Ian Atchison, Shawn Nash, Jeanine Panek**
Producer: **Philip Malkin**
Programmers: **Irv Kalb, Kevin Flores**
Writer: **Ira Ruskin**
Authoring Program: **Macromedia Director**
Platform: **Mac/Windows**
Digital Video: **Shawn Nash**
3D Graphics/Environments: **Jeanine Panek**

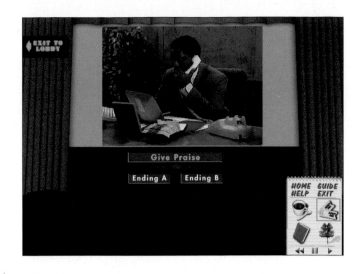

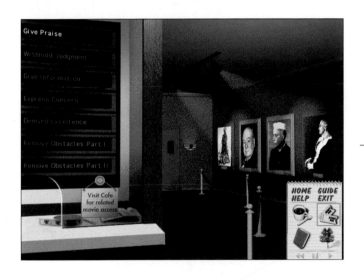

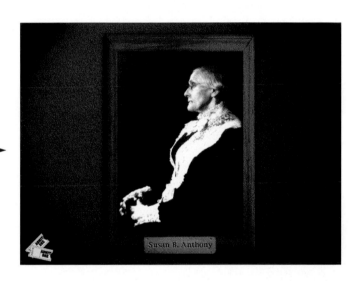

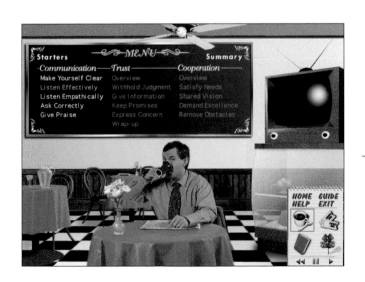

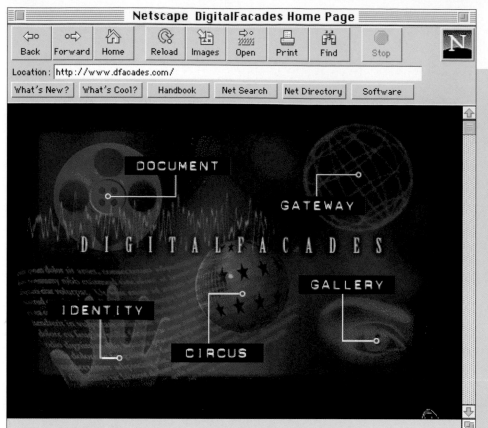

DigitalFacades' Web portfolio is built around a beautiful illustration that invites the viewer to explore the various areas of the company's site. Conceptual icons are woven into the illustration, which has been image-mapped to link to each area.

Subsequent links continue the look and feel of the home page image with top banner art, and each page offers a humorous or interesting quote for the viewer to read.

The DigitalFacades Website not only offers detailed information for the viewer to navigate through, but also makes it easy to return to the home page at any level of the Website by placing a "return to home page" button at the top of each page.

Project: **DigitalFacades Website**
Design Firm: **DigitalFacades**
Designer: **Oliver Chan**
Programmer: **Jane Lin**
Authoring Program: **HTML**
Platform: **Browser Related**
URL: **http://www.dfacades.com**

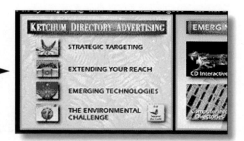

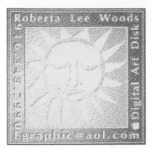

Roberta Woods' portfolio exemplifies the idea that an interface need not be intricate and involved in order to be effective. Her rich illustrations, beginning with the texturally illustrated main screen, create a consistent look and feel throughout the presentation.

The colors and lighting used on the main screen complement the smaller icons in the center. Clicking on these icons brings up a larger image of the original work, and though it takes only a few minutes to navigate the presentation, the illustrations are sure to compel the viewer to experience them again.

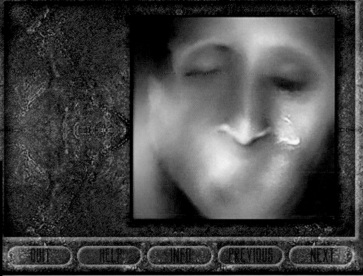

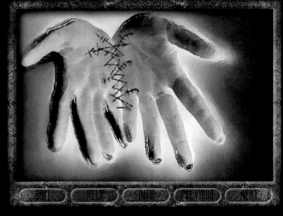

Project: **Interactive Portfolio**
Design Firm: **Roberta Woods Design & Illustration**
Designer: **Roberta Woods**
Interface Design: **Stirling H. Alexander**
Authoring Program: **Macromedia Director**
Platform: **Mac**

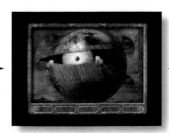

URL: http://barclay.fr/gb.html

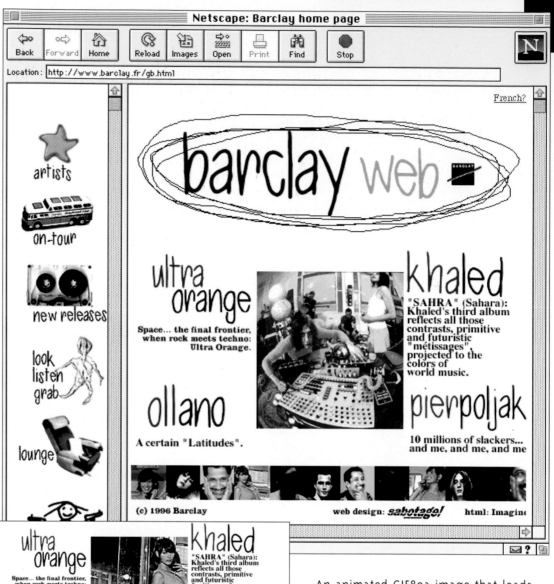

Netscape: Barclay home page

Location: http://www.barclay.fr/gb.html

French?

artists · on-tour · new releases · look listen grab · lounge

barclay web

ultra orange
Space... the final frontier, when rock meets techno: Ultra Orange.

ollano
A certain "Latitudes".

khaled
"SAHRA" (Sahara): Khaled's third album reflects all those contrasts, primitive and futuristic "métissages", projected to the colors of world music.

pierpoljak
10 millions of slackers... and me, and me, and me

(c) 1996 Barclay web design: sabotage! html: Imagine

COMMERCIAL

Barclay Web, the music 'zine designed by Sabotage! Entertainment, serves as a great resource for anyone interested in finding out about alternative European bands and artists. The site features a large listing of artists, tour dates, and downloadable music clips from various artists, as well as a "Lounge" area where viewers can exchange information on their favorite artists.

All the Website's features are available in French and English. Viewers can access either language by clicking on the hyperlink at the top of the main frame. Because the link is in this position, viewers don't have to wait for the full page to load before choosing which language to visit in.

An animated GIF89a image that loads in the middle of the main frame greets visitors, cycling through photographs relating to the four current features listed on both sides of the page. A navigation bar at the bottom of the page presents viewers with a link to past features.

vu → look

entendu
listen →

pris
grab →

Artistes **GIF** Artists

Tournées On Tour

nouveautés new releases

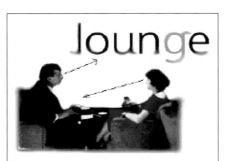

lounge

The creative use of easily recognizable icons and staggered typography immerses viewers in a contemporary, MTV-like atmosphere as they navigate the site.

Project: **Barclay Web**
Design firm: **Sabotage! Entertainment**
Designers: **Guillaume Wolf, Améziane Hammouche**
Features: **GIF89a animation, downloadable files**

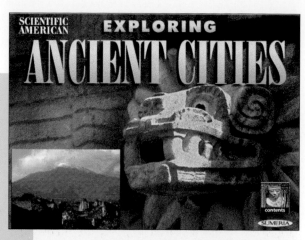

Exploring Ancient Cities, a creative venture from *Scientific American* and Sumeria Inc., examines four lost cities from antiquity: Teotihuacán; Petra, in present day Jordan; Pompeii, the Roman town once buried in lava; and Minoan Palaces on the island of Crete.

The CD-ROM uses an attractive, simple interface. Clearly labeled icons on the contents screen and identifying images representing the four cities are placed on a weathered stone background. The designers maintain continuity from this opening screen by using the identifying images as backgrounds on successive screens.

Exploring Ancient Cities blends text-based information in the form of comprehensive essays by respected archaeologists with visual learning aids in the form of a scrolling timeline, city maps and reconstructions, as well as a wealth of photographs.

One of the ways to take in the CD-ROM's content is a self-running tour, narrated by Rod McKuen.

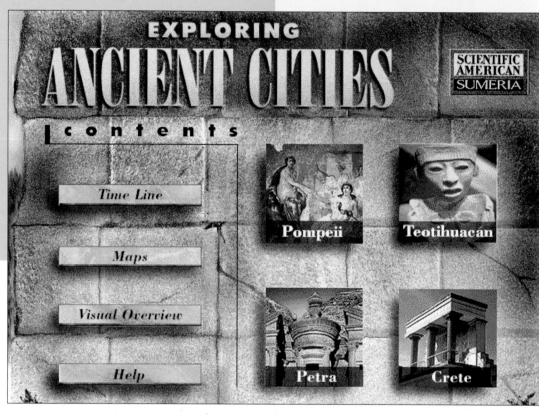

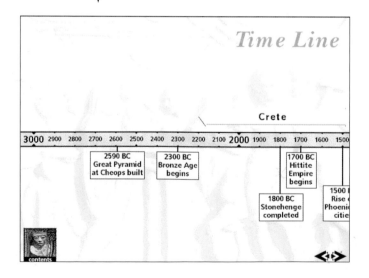

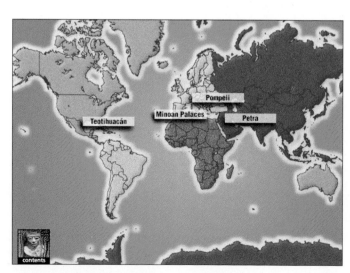

Vizbyte's home page shows what is possible when a minimalist approach is taken with interface design. Rewarding for adventurous people who enjoy exploring interfaces, the home page image offers a minimum of description, with no clearly defined buttons for navigation.

Visitors who want information immediately upon entering need only scroll to the bottom of the page for hypertext links. The introductory graphic is divided into four distinct quadrants, delineated by muted colors. Clicking on one of these quadrants leads to other areas of the Website, such as a company portfolio and bios of the designers.

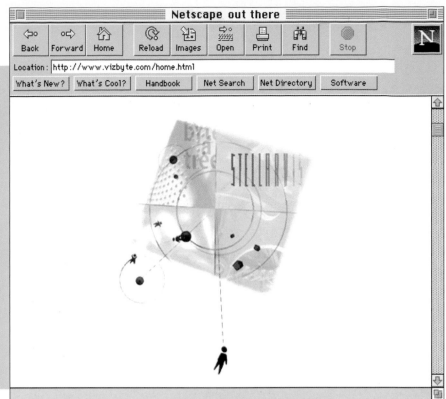

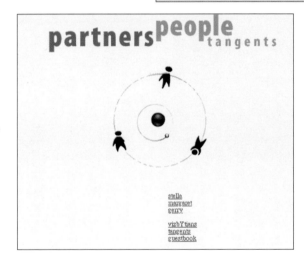

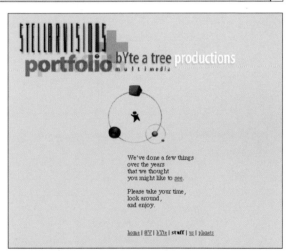

Project: **Vizbyte Website**
Client: **bYte a tree productions/Stellarvisions**
Design Firm: **bYte a tree productions**
Designers: **Stella Gassaway, Don Haring**
Illustrator: **Don Haring**
Programmers: **Gerry Mathews, Margaret Anderson**
Photographer: **Gerry Mathews**
Authoring Program: **HTML**
Platform: **Browser Related**
URL: **http://www.vizbyte.com**

The Soul Coughing interactive press kit shows Aufuldish & Warriner's solution to the great challenge of designing for the floppy disk medium: compression. Fitting as much information as possible onto a 1.4-MB floppy—while keeping the project interesting and entertaining—can be a real challenge.

The designers of this press kit have met this challenge by using 1-bit color graphics, allowing them to place many images in the project and use the space efficiently. Realistic photos are kept at a minimum and are used only at smaller sizes; larger images are manipulated to look good with limited color palettes. Optimizing palettes and using 1-bit images results in a rough, pixellated look, which the designers have used to their advantage for Soul Coughing. By keeping visual elements small, the designers avoid excessive compression of the sound files, which would result in distortion. This allows three songs from the album to be featured as sound loops, activated when the cursor is rolled over hotspots on the interface.

Three elements of the interface are particularly engaging: first, the use of constantly moving images—nothing is static, objects are always sliding, jittering or blinking on and off to the strong beat of Soul Coughing's music; second, draggable text blocks of song notes and concert dates invite user interaction with the interface; finally, each screen features hotspots where other imagery and animations are revealed when the cursor is passed over them.

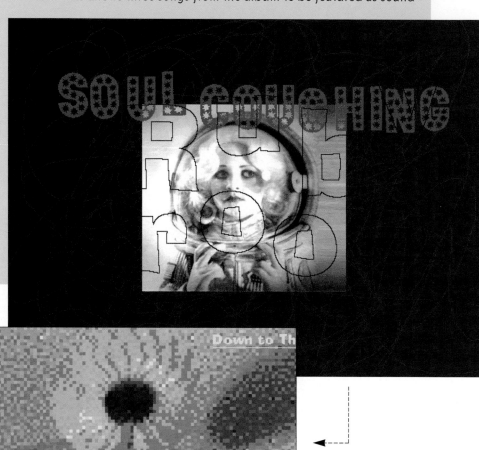

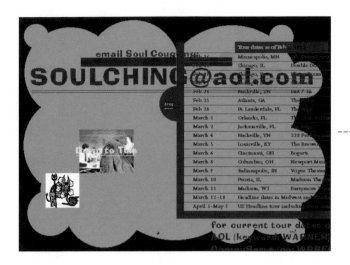
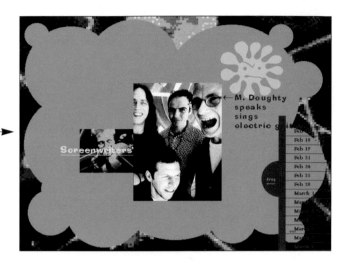
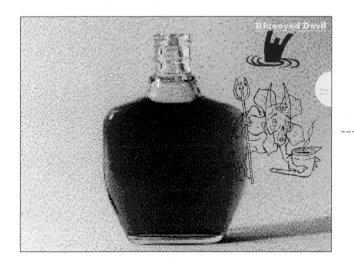

Project: **Soul Coughing interactive press kit**
Client: **Warner Bros. Records**
Design Firm: **Aufuldish & Warinner**
Art Director: **Bob Aufuldish**
Art Director (Warner Bros. Records): **Kim Biggs**
Creative Director (Warner Bros. Records): **Jeri Heiden**
Programmer: **Bob Aufuldish**
Authoring Program: **Macromedia Director**
Platform: **Mac/Windows**

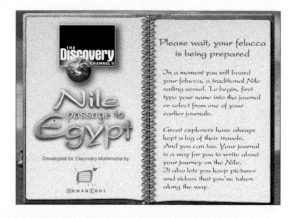

Nile: Passage to Egypt starts aboard a *felucca*, an ancient boat, used as the main navigational vessel for exploring the CD-ROM. The designers creatively incorporate the remaining navigation and learning elements into the prow of the *felucca*: a camera for taking pictures on the journey, a journal, compass, map, video viewer, and a magic lamp. Each of these items comprise a creatively designed interface that allows further exploration and game playing. The interactivity, games, 3-D animation, and stylized art all work together to create a beautiful, enjoyable, and educational interactive.

To fully engage the user, the designers created text editors, so that those who take the journey can keep a journal. Taking a snapshot with the camera sends a virtual photo directly into the journal for later viewing, while at the same time adding text about the object photographed.

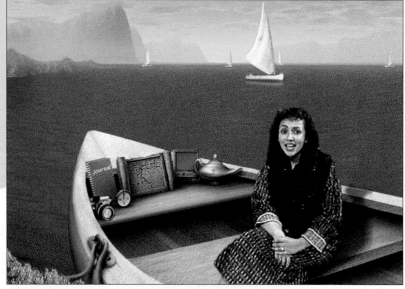

Project: *Nile: Passage to Egypt*
Client: **Discovery Channel Multimedia**
Design Firm: **Human Code, Inc.**
Designer: **Kyle Anderson**
Illustrators: **Maria Vidal, Chris Mead, Charles Furlong**
Photographers: **Saba Press, Thomas Hartwell, McKinnon Films, Michael McKinnon**
Programmer: **Brian Brantner**
Producer: **Lloyd Walker**
Audio Producer: **John Malcolm Smith**
Music Composition: **Mark Connelly Wilson**
Asst. Producer/Digital Video Prod: **Mary Flanagan**
Authoring Program: **Macromedia Director**
Platform: **Mac/Windows**

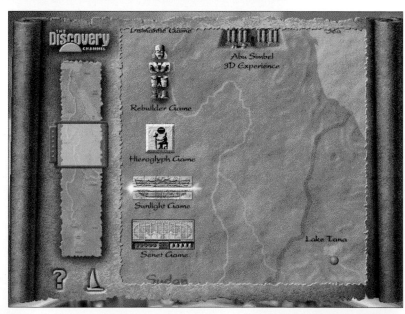

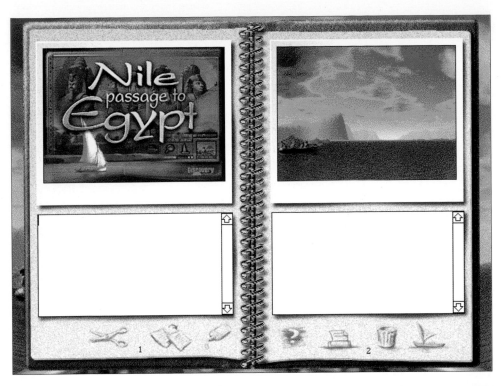

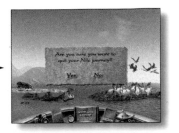

PPM& (LifeLines) is elegant in its simplicity. The interface is simple, with a row of navigable buttons running along the bottom of the screen, scrolling text, and photos that change when clicked upon. This design stands apart from others in its subtle use of colors and the use of a hummingbird (with flapping wings) as a cursor.

Moving the hummingbird from left to right switches the direction of the bird, and clicking on a button sends you to another screen accompanied by a trilling bird song.

Peter, Paul & Mary, the legendary trio that celebrates its 35th anniversary this year, announces the April 11 release of PP M&: LifeLines (Warner Brothers Records), an album unlike any they've recorded before.

Project: *PPM& (LifeLines)*
Client: **Warner Bros. Records**
Design Firm: **Post Tool Design**
Designers: **David Karam, Gigi Biederman**
Illustration: **David Karam, Gigi Biederman**
Authoring Program: **Macromedia Director**
Platform: **Mac/PC**

The Kid
Words and music by Buddy Mondlock
Lead vocals: Peter, Paul & Mary

Project: **Faith No More:** *King For A Day/Fool For A Lifetime*
Client: **Warner Bros. Records**
Design Firm: **Post Tool Design**
Designers: **David Karam, Gigi Biederman**
Illustration: **Eric Drooker "Flood! A Novel in Pictures"**
Authoring Program: **Macromedia Director**
Platform: **Mac/PC**

Faith No More's floppy disk-based promotion shows how technical and artistic elements are integral to Post Tool Design's interactive multimedia. In this project, the screens are layered with text and photos, and "graphic novel" style menu buttons at the bottom of every screen serve to unify the presentation.

The screens lead the viewer into an interactive playground that cannot be duplicated in any other medium. One screen is filled with pieces of art, text, and photos, which the viewer clears away by clicking on each piece in a "cleansing" process; another is blank until the viewer selects an image to draw with, creating his or her own ephemeral art.

 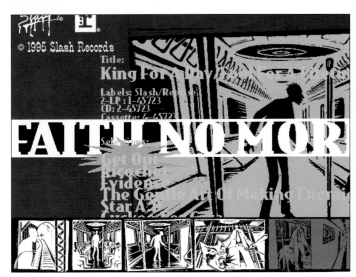

DIGITAL PORTFOLIO

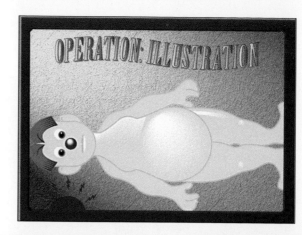

Jack Harris' portfolio piece takes a familiar interface—the childhood game of Operation—and turns it into a navigation device. With this interface the designer has had to do very little in the way of instruction in the use of the interface, and has let the familiar game concept carry the weight—making accessing and navigating the interface easy for even the novice user.

Similar to the American board game of Operation, the user moves the cursor over the icons located around the body, and then clicks on each one to go to the next screen. Rolling the cursor over the image of the computer chip brings up the phrase "chip on the shoulder" in the text box. Clicking on the image then takes the user to the full portfolio piece.

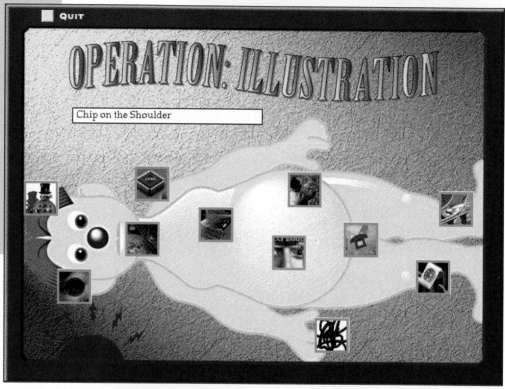

Project: *Diskfolio 2: Operation Illustration*
Design Firm: **Visual Logic**
Designer: **Jack Harris**
Illustrator: **Jack Harris**
Programmers: **Jack Harris, Katie Houghton**
Authoring Program: **Macromedia Director**
Platform: **Mac**

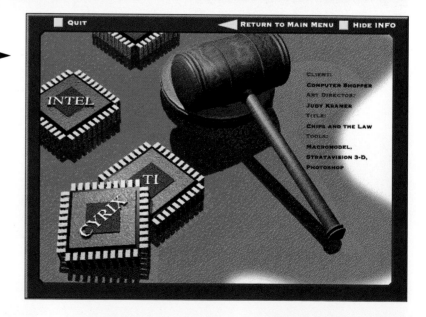

Ginny Westcott's interactive portfolio and resume shows that working knowledge of a multimedia program such as Macromedia's Director—combined with creativity and high-quality design skills—produces a very satisfying interactive experience.

The Matisse-like cut paper images used as buttons clearly illustrate the main components of the resume; primary colors elicit a sense of vibrancy and directness in the piece, and at the same time keep the file size small enough to fit on a floppy disk.

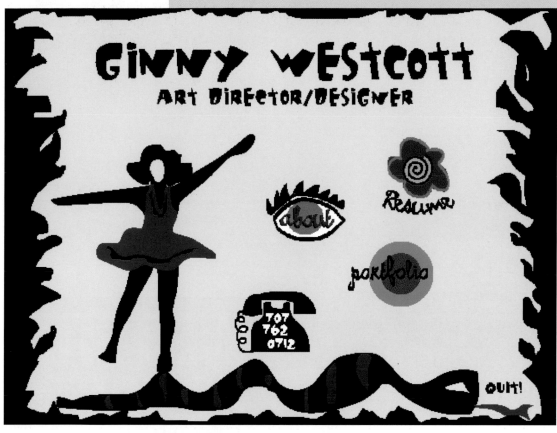

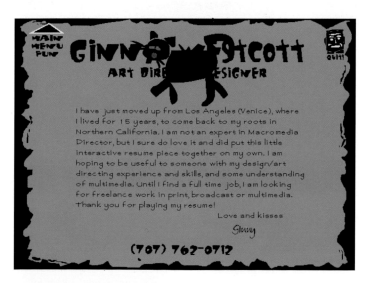

Project: **Interactive Resume and Portfolio**
Design Firm: **Ginny Westcott**
Designer: **Ginny Westcott**
Authoring Program: **Macromedia Director**
Platform: **Mac**

 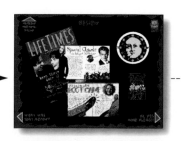

DIGITAL PORTFOLIO

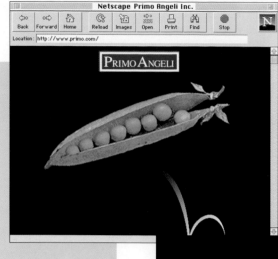

Primo Angeli's Web portfolio shows the simplicity and impact of a well-packaged design. Well-known for its traditional print design, the firm quickly is becoming a leader in multimedia design as well.

As a brand and packaging design firm, the company knows how to get a message across in small spaces, and the Web is a perfect crossover medium for this aspect of the business.

Large images and typography convey their messages clearly, and put emphasis on content rather than the navigation.

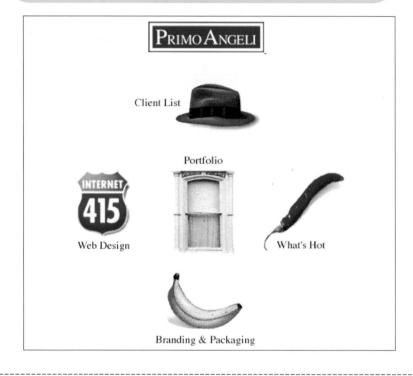

Project: **Primo Angeli Inc. Website**
Design Firm: **Primo Angeli Inc.**
Creative Director: **Primo Angeli**
Art Directors: **Primo Angeli, Brody Hartman**
Designers: **Philippe Becker, Dom Moreci**
Illustrator: **Mark Jones**
Programmer: **Dom Moreci**
Authoring Program: **HTML**
Platform: **Browser Related**
URL: **http://www.primo.com**

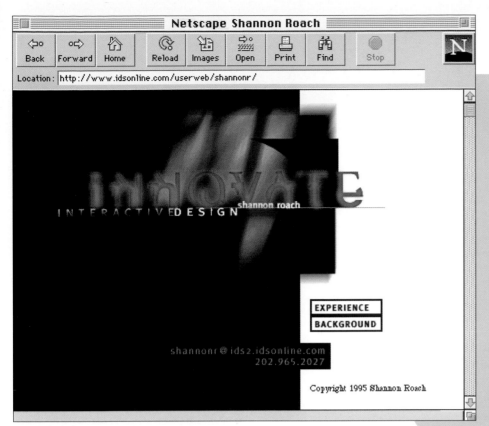

Shannon Roach's Web design is both innovative and contemporary, as the home page to this site clearly shows.

The hard edges of the black-and-white space that divides the page complement the drop shadows, layered headlines and modern type treatments.

The blurred swatch of gold blended into the heading adds depth and movement to the interface.

Only two buttons reside on the home page, both clearly labeled for easy navigation. Shannon's flair for creating high-quality, contemporary design is not limited to her personal work; the portfolio area of her Website demonstrates her ability to adapt this style to many different commercial and professional projects.

Project: **Personal Website**
Design Firm: **Shannon Roach**
Designer: **Shannon Roach**
Authoring Program: **HTML**
Platform: **Browser Related**
URL: **http://www.idsonline.com/userweb/shannonr**

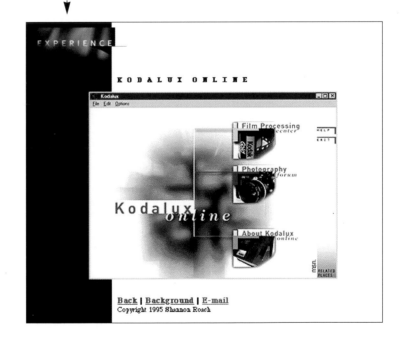

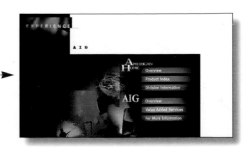